Create Dramatic Coastal Scenes

IN WATERCOLOR

CARLTON PLUMMER AWS

international **artist**

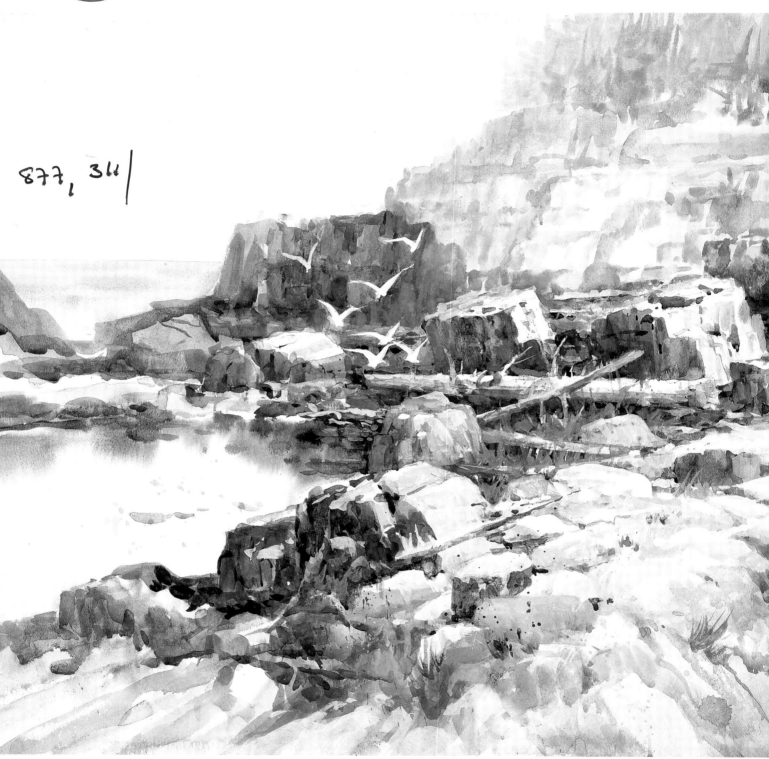

Winter Tidepool, 20 x 30" (51 x 76cm)

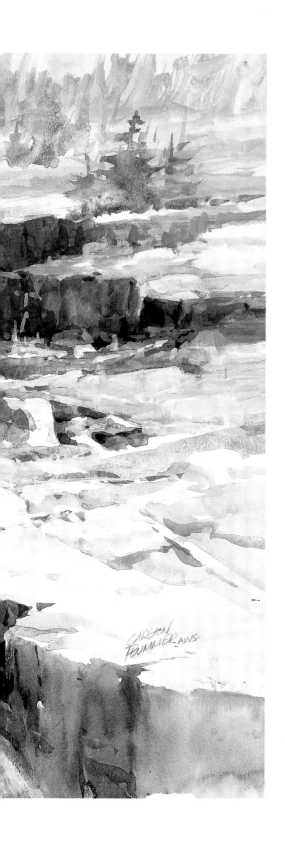

Create Dramatic Coastal Scenes
IN WATERCOLOR

CARLTON PLUMMER AWS

international
artist

International Artist Publishing, Inc
2775 Old Highway 40
P.O. Box 1450
Verdi, Nevada 89439
Website: www.internationalartist.com

Edited by Jennifer King and Terri Dodd
Design by Vincent Miller
Typesetting by Lisa Rowsell,
Cara Herald and Ilse Holloway

ISBN 1-929834-37-3

Printed in Hong Kong
First printed in hardcover 2004
08 07 06 05 04 6 5 4 3 2 1

Distributed to the trade and art markets
in North America by:
North Light Books,
an imprint of F&W Publications, Inc
4700 East Galbraith Road
Cincinnati, OH 45236
(800) 289-0963

Acknowledgments

This book is dedicated to my wife Joan who has been
the force that drives me beyond the boundaries. A very
talented artist in her own right, Joan's loving support
and guidance extends to our entire family of four sons,
ten grandchildren and four daughters-in-law, being there
when it mattered the most.

A special appreciation goes out to my four sons and
grandchildren who put up with the old man's "artistic
temperament."

Thanks to all my students who have provided me with
photos of painting demonstrations, many of which have
been used for the book. After all, this book is a byproduct
of my many years of teaching painting.

Thanks to *International Artist* magazine publisher,
Vincent Miller, for urging me to write a book on marine
painting and to Jennifer King for her skillful editing of my
manuscript, her patience with me and her ability to always
have the right answers to my questions. A special thanks
goes to Trudi Hendrichs, my efficient typist who has made
my job of writing this book easier.

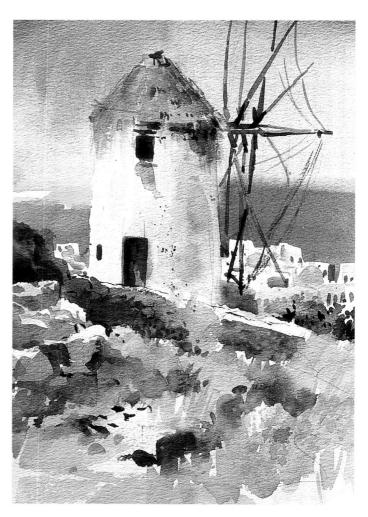

Mykonos, Greece, 22 x 15" (56 x 38cm)

Foreword

For countless years, America's Maine coast has drawn artists to its shores. The salt marshes, lighthouses, mysterious sea mists and fogs, rock ledges, majestic pine-topped cliffs, and fishermen's huts and boats provide a never-ending source of subject matter for the seascape and landscape painter.

Carlton Plummer resides at East Boothbay, his home and studio overlooking the sea and the ledges that he loves with a great passion. The emotion he feels is clearly evident in his paintings of the constantly changing moods of an area that has remained pretty much untouched over the years.

Some years ago I had the pleasure of staying with Joan and Carlton and heading off in his boat with Carlton each morning to paint South Bristol, Damariscove Island and the Boothbay area. It was a wonderful experience to visit isolated spots and paint to the cry of the birds and the pounding surf, feeling that perhaps the two of us were the only people left in the world. I marveled at Carlton's knowledge of the local flora and fauna, the tidal movements, the signs of the weather's vagaries and his great enthusiasm for "getting it down" in watercolor.

His paintings capture the atmosphere, the altering colors of the sea and the movement of the huge tidal drops in such an evocative fashion that the viewer imagines the smells of the seaweed, the dampness and the salt-caked pilings.

Nobody paints it better than Carlton, and this book will allow us to enter his mind and his heart as he reveals to us his working methods and his motivation.

Robert A. Wade AWS

Table of contents

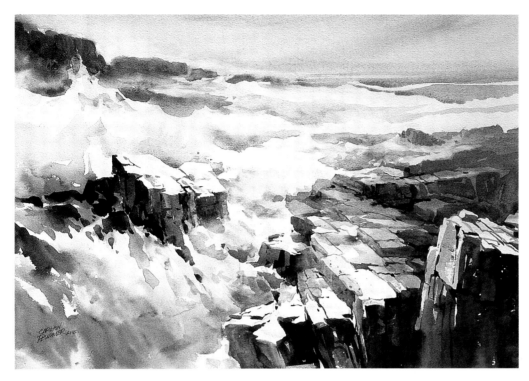

Rising Surf,
15 x 20" (38 x 51cm)

Mr. Trask's Fish House,
15 x 22" (38 x 56cm)

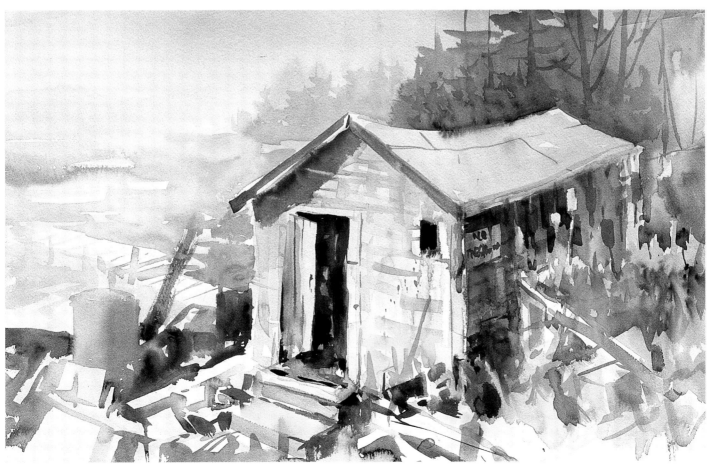

Introduction

Living most of my life on the coast of Maine with the Atlantic Ocean as my backyard, I have found endless artistic inspiration from the varied views of this beautiful coastal environment and in the human activity that accompanies this way of life. From this subject matter, I have found qualities I favor in art — primarily drama and energy shared with moments of quiet serenity, reminiscent of my personality.

No matter where you reside — if not by the sea, then perhaps near a lake, a river or even a pond — you have undoubtedly picked up this book because you have discovered a similar interest and wondered how best to paint these fascinating subjects. While this book will definitely explore the specifics of painting waterways and the coastal environment, mainly in watercolor, this subject is also a vehicle for understanding visual and written information regarding my overall approach to creating art.

Through a series of coastal paintings that span much of my 40 years as a professional painter and art educator, I will explain my larger process of painting, particularly in terms of design structures and the keys to drama. Regardless of subject, painting is about making decisions involving both technical and intuitive thinking, and the lessons I will share here actually apply to any and all subject matter.

In addition to many finished paintings, step-by-step illustrations with explicit descriptions in the captions are interspersed when needed as an integral part of the learning process. However, I do this with mixed feelings. Sometimes too much shared knowledge can produce clones, so I encourage you to develop your own style.

My aim is to help you design paintings with more ease but also to lift you to another level of thinking that will help you find your true voice: Capturing the true essence of a scene is important, but so is revealing the true spirit of your inner self. This can be transmitted through brush strokes and choice of design structure, value pattern and color.

It is hoped that this blend of philosophy and technical information will evoke and inspire exploration and experimentation as you continue to grow as artists. As I often say to my workshop students, "Take what you need from me, keep your options open and enjoy the creative process."

Remember, experience is also a good teacher. The more you paint, the better you get. I remember a student once saying to me, "Carlton, you are one lucky guy." My reply to that student was, "Yep, the harder I work, the luckier I get!"

Enjoy the book and Happy Painting!

CARLTON PLUMMER AWS

Island Mist, **15 x 22" (38 x 56cm)**
One of my favorite scenes to paint is Green Island, especially in a misty, mysterious mood. This was a demo for my students. Working directly without drawing, except a little with a brush, I got into the composition quickly in order to catch the mood before it changed. Notice how simply the rock shapes are stated. The island silhouette is just a value darker than the sky.

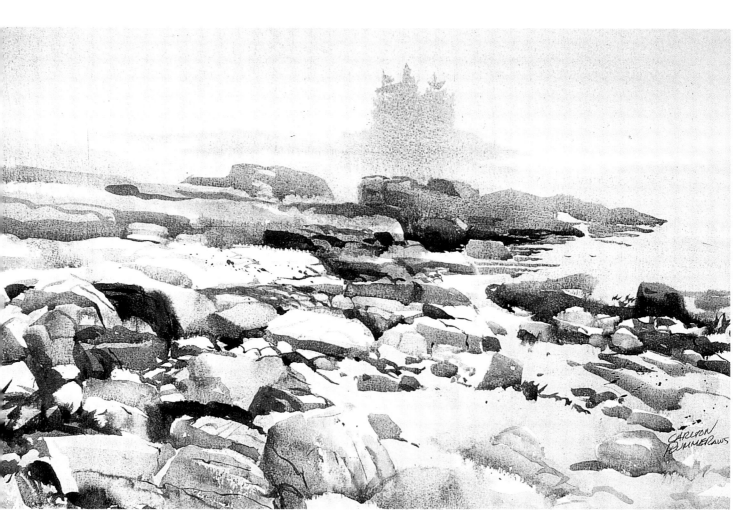

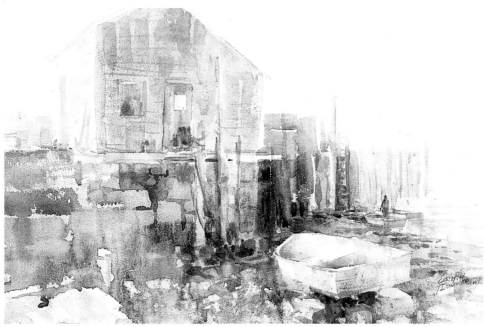

Misty Fish House,
15 x 22" (38 x 56cm)
Cool, high-key tones of mauve form a
silhouette that includes the building and
the wharf. The low tide area below it is an
extension of the same light value. I added
warm, Raw Sienna brush strokes while
the silhouette was still wet (same value,
different color) maintaining the flatness
and simplicity of the shape. A few relatively
darker accents were added but the painting
remains a high-key painting with little
contrast, capturing that typical warm,
misty mood of the Maine coast.

Painting with watercolor will get a whole lot easier when you discover which materials are right for your needs.

Getting to know your materials

When it comes to painting, your personal message is important, and you should be able to convey it without a constant struggle. Yet many of us, especially if we're just beginning to work with watercolor, compromise quality for price and buy materials that make the process so much more difficult. Watercolor is tough enough without the aggravation of an unforgiving paper, dull or grainy pigments and brushes that lose their shape or leave a trail of hairs across your paintings. So before we get started, let's review some of the quality materials you can use to make your painting experience more enjoyable and successful.

Choosing your paper

With so many good papers on the market, there is sure to be more than one that will fit your personal artistic needs. Some of the factors to consider when choosing a paper are the weight; the whiteness; the surface finish (hot-pressed, cold-pressed or rough); the ease with which the pigment flows and interacts once it hits the paper; its ability to allow easy lifting of paint, glazing and layering of paint; and finally, the drying time.

The weight of the paper is a major factor in how much water your painting can absorb without buckling. If you want to avoid buckling but don't want to stretch a piece of paper, use a 300lb or higher weight paper (although I use 140lb cold-pressed without too much buckling).

Watercolor paper comes in a great variety of whites that range from almost pure white to cream or gray tones, some warm and others cool. This is simply a matter of preference. If you are into color and like to paint sunlight, then a whiter surface will allow you to create wonderfully luminous effects. If you tend to use neutrals or more somber colors, then you may prefer to use one of the off-white papers.

Surface finish is influenced by how you like to paint and what you'd like to achieve. A hot-pressed paper is a smooth, harder finish that allows the pigment to sit on top of the surface, puddle up and create variations as it runs around the paper. The pigment won't sink in as much and can be pushed around while it is wet. When it dries, the paint can easily be lifted with water, allowing for corrections and modeling. You can also achieve more fine detail with this finish. However, it is more difficult to glaze or apply wet-on-dry on a hot-pressed surface without disturbing the first layer.

A rough surface is much more absorbent, so the pigment tends to sink in to this surface. Because this paper is already textured itself, it is excellent for textural effects, such as drybrushing or spattering, and for loose, bold techniques.

The cold-pressed surface lies somewhere between the other two, possessing many of the qualities of both the hot-pressed and rough finishes. Perhaps this is why it's the most popular with watercolorists.

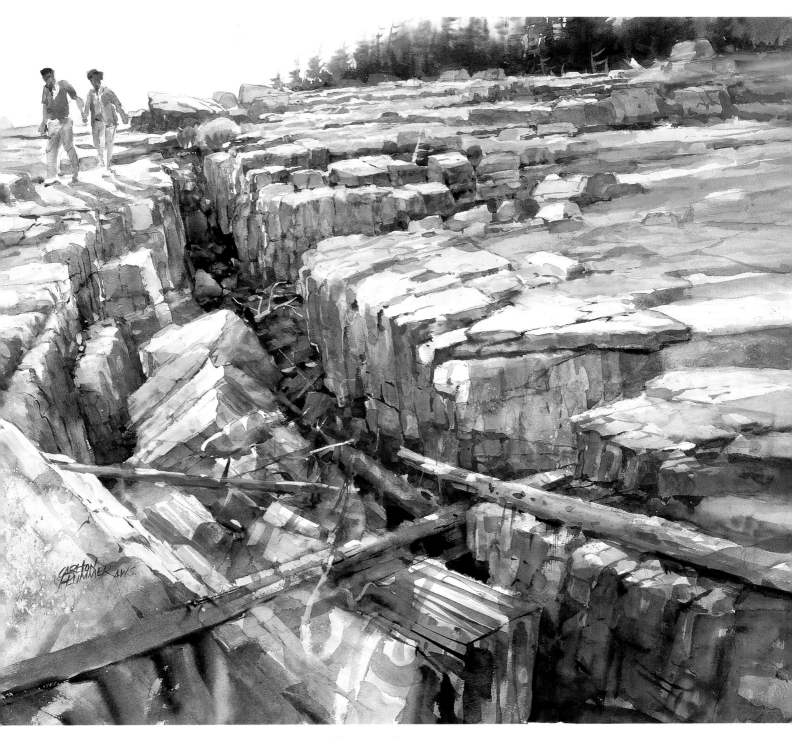

Acadia Figures, 21 x 28" (54 x 71cm)
The massive ledges at Scoodic Point, Acadia National Park, are accentuated by the high horizon and the introduction of two rock explorers to show scale. I invented driftwood to break up the foreground ledges. The deep crevice in the rocks creates drama and intimidation. To complement the warm-colored ledges, I used a semi-opaque glaze of white gouache and watercolors to cast a bluish tone over the ledges on the middle right.

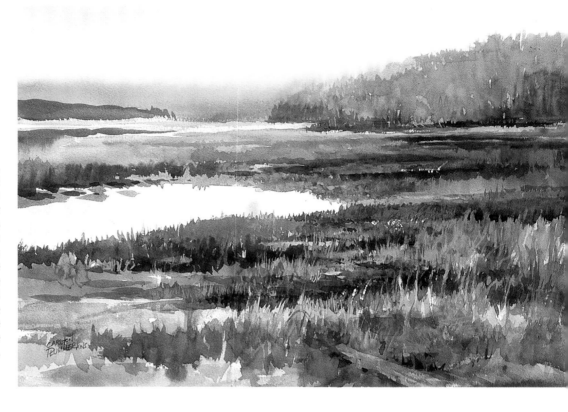

Salt Marsh,
15 x 22" (38 x 56cm)
The strength of this composition comes from is strong use of color and value contrast, providing us with an intense mood based on late-day light. However, there are a few subtle areas in the middle foreground where a little white was mixed with the greens to add depth. The contrast of the transparent passages against the subtle opaques contributes to the luminosity of the painting.

"It will be important for you to discover firsthand the characteristics of various colors, such as covering ability, transparency, durability and the degree of staining."

There are actually about six different surfaces I like to use, but the only way for you to discover which brands and makes have the qualities you prefer is to experiment. Buy various sheets of high-quality watercolor paper or board (such as illustration board or bristol board), cut them into quarters, label them and try some of the watercolor techniques I will explain in Chapter 2. As you work, study how your pigments are behaving on the different surfaces and finishes. You can also experiment with coating your board or paper with acrylic gesso before painting. Be sure to keep notes on the results of your tests, and always remain open to new ideas. What may not work for you right now may be just right for an idea you want to pursue later.

And here's a tip on stretching: Because I use heavyweight, high-quality paper, I find I don't really need to stretch my paper beforehand. If you'd like to try my easy approach, adhere two pieces of foam-core board together and simply use heavy spring clips to attach your paper to the board.

Selecting brushes

A watercolorist needs a fairly expansive selection of brushes. It is important to have a number of round brushes that come to a point. Highly versatile in its uses, a good round brush will respond to pressure and should snap back to a point when you release the pressure. My largest round is a No. 40, but I only use the very small sizes when I'm painting miniatures.

You'll also need large, medium and small flats to cover large areas and to paint hard edges and geometric shapes. I also recommend a unique brush called "The Cat's Tongue" that is flat at the base, shaped like a shield and comes to a point. It is very resilient and flexible.

I recommend having a fairly wide range of sizes of both rounds and flats because a good selection offers more latitude in the quest for interpreting the coastal environment. The larger brushes will cover more ground faster without requiring unnecessary brush strokes, while the smaller brushes are ideal for finer lines and detail.

My favorite brushes range from synthetic and/or sable rounds from No. 5 up to No. 40, plus various flats and a shield-shaped "Cat's Tongue" brush. I keep them in a lightweight, folding canvas holder, which is great for studio or outdoor use.

***Abaco, Bahamas*, 22 x 28" (56 x 71cm), 140lb cold pressed paper**

Although there is a lot of activity in this composition, the boats are placed in a curved movement that lead you back to the red sailboat and figures, which are the focal area. The other figures are integrated into the composition, and the light fence forms a convenient backdrop for all of this action. I used transparent pigments very lightly, working both wet-into-wet and wet-on-dry.

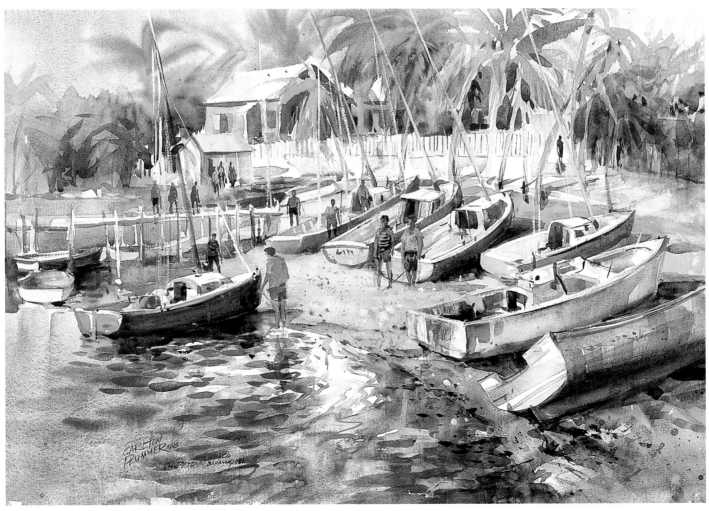

Viridian

Cadmium Lemon

Aureolin

Cobalt Turquoise
Light

Quinacridone
Gold

Prussian Blue

New Gamboge

Peacock Blue

Cadmium Orange

Cerulean Blue

The John Pike palette I use has more than enough deep wells on three sides for your choice of colors, and the lip is high enough to contain any extra water. The lid helps keep paints moist with a small sponge inside, and it provides another large mixing area.

Alizarin Crimson

Cobalt Blue

Although you will eventually decide on your own palette colors, these are my recommendations: five or six warm colors, five or six cool colors and a few earth colors. I use predominantly transparent colors because they mix, glaze and respond well in meeting my needs. Designer's white gouache is another item I like to have around for mixing watercolors into an opaque glaze.

Cadmium Red

Ultramarine
Blue

Permanent Rose

Burnt Sienna

Quinacridone
Rose

Raw Sienna

At one time, I thought it necessary to use only the finest Kolinsky sables, but they are quite expensive and the points have a way of deteriorating over time. I have since found more affordable, yet still high quality, alternatives. Although I still use a couple of Kolinsky sables, most of my dependable brushes — both rounds and flats — are synthetic or a combination of nylon and natural hair. Not only do they last a good long time, I don't need to mortgage the house to buy them!

Arranging your paints

Buying good quality pigments is also essential to successful painting. Just as with so many other materials, you get what you pay for. Cheap colors do not respond well and will fade quickly. Believe me, there is no comparison between artist's quality paints and the student-grade stuff.

When working in the studio, I prefer to use watercolor from tubes because it allows me to squeeze out as much fresh paint as I need each time I paint. I like to put my pigments in a palette that has a large mixing surface and many deep wells for the pigments. I also prefer a palette with a lid, which helps to keep leftover paints wet and clean for the next painting session.

Of course, every artist eventually settles in on a personalized palette of colors. However, I've seen many artists go overboard and buy just about every available color. This simply isn't necessary, and can be expensive and confusing. A dozen or so colors should be enough to round out your palette — five or six warm colors, the same number of cool colors and a few earth colors. The diagram of my palette shows one possible way to arrange a workable selection of pigments.

It will be important for you to discover firsthand the characteristics of various colors, such as covering ability, transparency, durability and the degree of staining. Usually the various manufacturers print that information, but the best way to get to know your paints is to work with them yourself on test sheets. Experimenting with overlaying colors will reveal the attributes and limitations of the colors you've chosen.

***Reflected Lights*, 22 x 28" (56 x 71cm)**
The impact area lies where the figures, the middle part of the boat and the water meet. Strong diagonals and verticals overlap here to further emphasize the focal point. However, the figures were a late addition to the painting. Because of the paper I was using, I was unable to lift off the pigment initially applied there, which is why I opted to mix a bit of opaque gouache into the paints used for these figures.

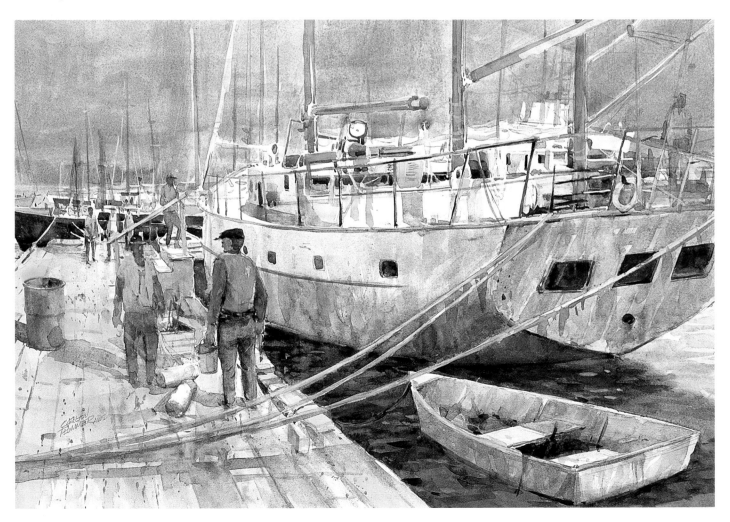

"When it comes to painting, your personal message is important, and you should be able to convey it without a constant struggle. Yet many of us compromise quality for price and buy materials that make the process so much more difficult."

Gathering other materials

For studio painting, I prefer to stand in front of a large, adjustable studio easel that accommodates a large surface. This allows me more freedom and gives me the chance to step back for an overall look at my work. However, there are times when I need or prefer to sit. For this, I use a drafting table, which can be easily adjusted for height and angle, and a drafting chair with wheels.

Whether you decide to sit or stand, you'll also need a large table for holding your other materials. In addition to your palette and brushes, you'll need several plastic containers for water, sponges, spray bottles and either cotton rags or paper towels for cleaning up.

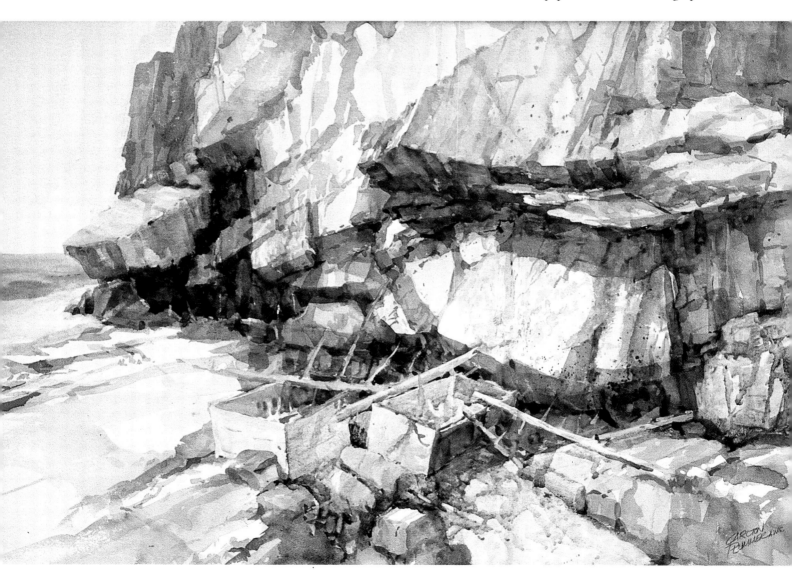

I like having a large work table in my studio so that I can lay out all of my painting materials next to either my flat painting surface or my easel.

If you've never tried painting watercolors upright at an easel, you may want to consider it. You just might like the way the water runs down the page, creating a looser, freer look. It also allows you to step back from your image repeatedly to review your progress. Note my brush holder and the angle of my drafting table.

(Left) *Ledge Maze II*, **21 x 29" (54 x 74cm)**
Although much of this painting was done in transparent paint, it has a mixture of gouache and compressed "Char-Kole", a very soft black, pastel-like stick that mixes well with watercolor. These materials allowed me to achieve the exact effects I was after.

When painting outdoors, you'll want to travel light in case you want to walk a far distance over rough terrain to the best painting site. Your tote bag should contain: your paper, painting board with clips, fold-out palette, brushes, water containers, water, paper towels, camera, small sketch pad and pen. Don't forget drinking water and sunscreen. Your telescoping, aluminum, fold-up easel (and perhaps folding stool) can be carried separately for balance, and can easily be adjusted to stand up on even the rockiest terrain. Another benefit of an upright easel is that it keeps the painting out of direct sunlight.

Preparing to paint on location

Painting on location can be one of the most pleasurable experiences you'll have as an artist, but it does require some extra planning when it comes to your materials. Regardless of your intent, if you are to enjoy the time spent on location, you do not want to be burdened with unnecessary weight. It is especially important to travel light if you're flying overseas or if you plan to trudge over craggy, rough terrain or simply walk a long distance to get to the best painting sites.

There are several things you can do to lighten your load of painting materials. One is to use a compact, fold-out palette that contains a limited number of pan colors. Another is to limit your number of brushes, or use

the telescopic brushes made for use with outdoor palettes. These items, along with some paper cut to size and clipped to your foam-core board, plastic water containers, rags, your camera, small sketch pad and pen should all fit in a canvas tote. Carried separately, a lightweight, telescopic, aluminum easel and a fold-up stool will make you comfortable at any location. The easel will adjust to a variety of heights and angles to fit the terrain, and can be used while sitting or standing. Just be sure to wear sunglasses, sunscreen, a brimmed hat and comfortable walking shoes.

Now that you've gathered together your quality materials and have experimented with the colors and papers you like best, it's time to get started on painting dramatic coastal scenes.

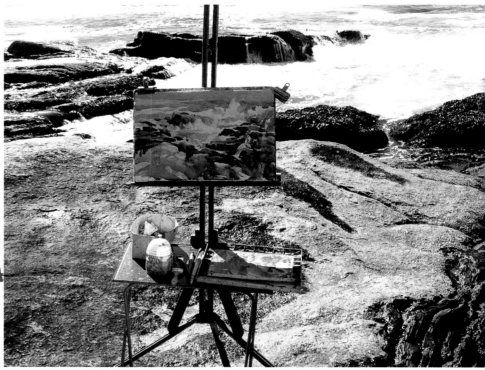

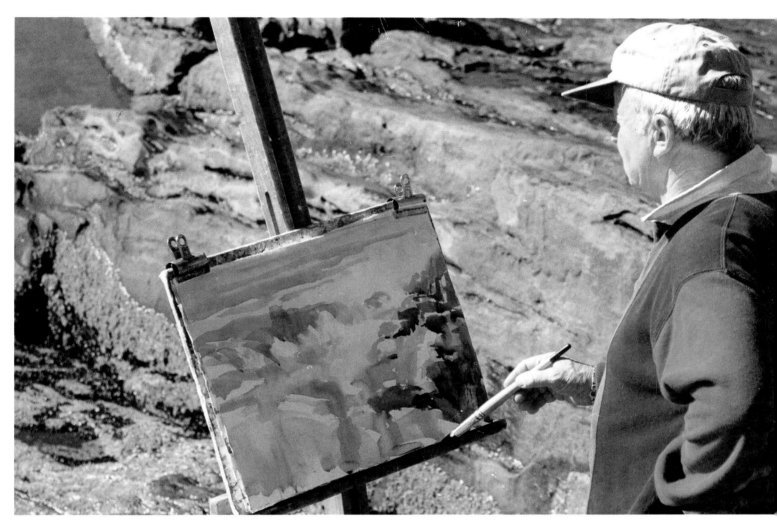

How to fix a buckled painting

Occasionally, a painting will buckle to the point that it's difficult to mat and frame. To solve this problem, re-wet the painting on the reverse side, lay it between multiple, large sheets of clean paper (blank newsprint used for sketching works well for this) and weight it down with some heavy books or objects until it dries.

Two pieces of foam core glued or taped together make an ideal mounting board for the paper — very light and inexpensive. I clip unsoaked paper onto the board with metal spring clips so I can adjust the paper if it expands with added moisture.

"Regardless of your intent, if you are to enjoy the time spent on location, you do not want to be burdened with unnecessary weight."

You can achieve any look you want when you have full control over your medium and materials, so learn to master the following basic techniques.

Experimenting with basic watercolor techniques

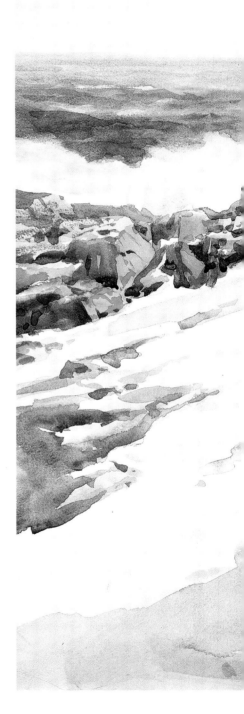

In the process of developing a painting, technique and creativity go hand-in-hand. You can be as creative as you want to be when you have the ability to utilize watercolor's attributes to its fullest. Although it's possible to be creative without clever techniques, or to be accomplished in your handling of a medium without being particularly creative, the ideal is to have a balanced blend of both.

This is where experimenting with watercolor techniques come into play. I urge you to get out your materials discussed in the previous chapter and get to work on mastering these fundamentals so that you can proceed to confidently explore the more expressive side of art.

Working wet on dry paper

Applying pigment onto a dry surface is the most common way of painting with watercolors. It's easier to control and more predictable. When working wet-on-dry, the best approach is to allow the brush to continue the shape quickly without too much overworking, which creates a clear, simplified area. Clarity is very important in painting because the transparent quality of the watercolor can then allow the white of the paper to reflect light and illuminate the color. If you need edges that are more distinct or sharp, wet-on-dry is also the technique to use.

Glazing

When a transparent wash of a second color is applied over a thoroughly dry, previously applied color, the technique is known as "glazing". Again because of the transparent nature of watercolor, the initial application will show through and influence the glaze; in essence, the two will combine to create an entirely unique color.

Many layers of glazing, if clear and transparent, can be applied to a painting. The traditional English watercolorists often created entire paintings using this approach, building up multiple layers to yield a jewel-like effect. This technique is also very effective in adjusting or modifying the value, color or intensity of certain sections of the painting. It is especially effective in dramatizing the mood of a painting where lighting becomes a factor.

Drybrushing

One special way of painting wet-on-dry is called "drybrushing", although the brush isn't dry when using this technique. It works best when you use a paper with a tooth (texture) and load the brush with fairly thick, dry pigment (without too much water). The trick to drybrushing is to touch your brush to the paper with a gentle touch that lightly drags across the surface, allowing the texture of the paper to pick up the paint in a broken brush stroke. This is a very effective way to

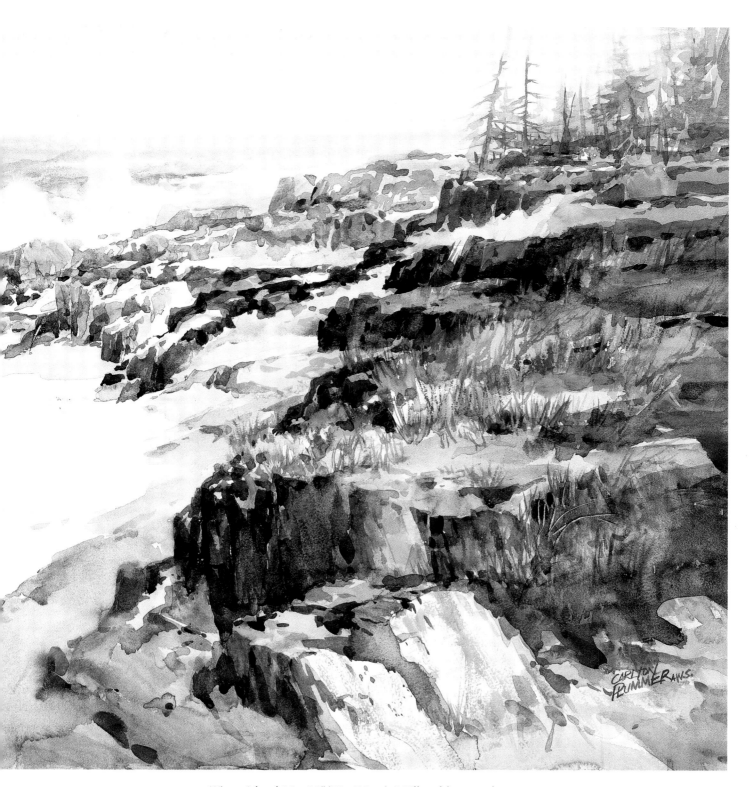

Winter Island, 22 x 30" (56 x 76cm), 140lb cold pressed paper
This painting turned out to be an award winner many times over. Perhaps it has much
to do with the drama that the lighting and zig-zag composition have to offer. I painted
primarily wet-on-dry, leaving lots of white paper to give the feeling of light and snow.
The loose brushwork showing the surf and vegetation is wet-into-wet, and the ledges
were created through glazing.

simulate texture, such as the surface of an old building, roadway, field or rippling water. An entire painting can be executed with this technique or it can be limited to areas that require texture.

Learning to paint wet-into-wet

An alternate way to apply watercolor to paper is called "wet-into-wet", meaning applying wet pigment to an already wet surface. To many, this is the most formidable and challenging process, probably because of the uncertainty and unpredictability of it. I feel, however, that a wet-into-wet application is watercolor painting at its finest. It allows the pigments to flow and interact, creating diffused and unpredictable color — what excitement!

When working wet-into-wet, the paper needs to be charged with lots of pigment to compensate for the excess moisture. At first, it takes courage to apply that much pigment onto a very wet surface, but once you've "gotten your feet wet", you'll wonder what took you so long. The wet pigment doesn't necessarily have to be applied with a brush. Other methods of applying pigment wet-into-wet include dropping and spattering, each reacting with the paper in a different way.

Knowing how your paper will react to water and pigment is a very important factor in any wet-into-wet technique. As mentioned in Chapter 1, each paper will respond in different ways so experimenting with different surfaces is quite useful.

Laying in a wash

Using a wash to cover a large area of the paper is one of the most basic techniques in watercolor painting. Everyone who paints in watercolor should know how to lay in a wash.

The paper can be dry or wet. If it is dry, mix a large amount of wet, watery color that you want for this large area. Using a large, flat brush, start on the left-hand side and push the paint-loaded brush across to the right. Then turn the corner without lifting the brush off the paper and overlap the first stroke. Repeat until the area is covered.

A wet-into-wet wash is similar except the paper is wet to start with. This is an especially effective approach to use when you want to change the value or color of the wash as you move across the large area. You can control the value by adding more pigment and less water, and you can adjust the color simply by

gradually adding another color into your puddle of base color on your palette.

Suggesting texture

In addition to drybrushing, there are several techniques for creating texture. Salt dropped onto a wet or damp area of color will create a blotchy area reminiscent of texture. Dropping water on an area will give a similar effect, and is perhaps more effective than salt. Spraying clean water onto a wet surface will cause the paint to separate into small, light areas, another interesting effect.

Using liquid masking fluid

I do not use liquid masking fluid to save white areas in my paintings — I prefer to carve out around my whites with a wet-on-dry technique. However, there are times when it can be used effectively, so again I encourage you to practice applying the fluid and then glazing over the preserved areas so you don't have too many glaring white spots with hard edges.

Correcting errors

No matter how experienced you become, there will always be times when you may get a little too heavy-handed or fussy ➔

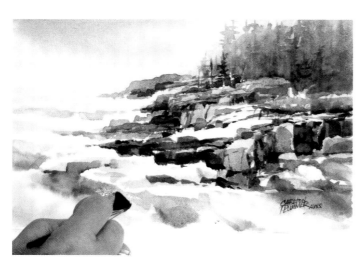

Working wet-on-dry, either in the initial stages or in later glazes, is a great way to define shapes with crisp edges and to pull areas together. The edges can be softened later if needed.

Drybrushing is a good technique for showing texture, as in these rough rocks in water. To drybrush, first charge the brush with lots of heavy, thick pigment. Then delicately, with a light touch, pull the brush across the paper, exposing broken white areas. If your pigment is too wet, you can always gently blot your brush on a paper towel before applying the paint. Note that drybrushing is easier to accomplish on a paper that has a tooth to it than on a smooth surface.

Don't be afraid to work wet-into-wet, especially in the initial washes used to establish your basic design. Allowing some of the color to run freely will create a looser look and provide more interesting color diffusions.

Hammer's Slough,
15 x 22" (38 x 56cm)
Taken with the sparkling reflections and light, I painted this on location in Alaska while waiting for the ferry to arrive. To capture the background mist, I painted the mountains wet-into-wet in values of muted blues and Raw Sienna, then lifted the pigment off with my brush while it was still wet. For the dark evergreens placed over this area, I initially worked wet-into-wet but then wet-on-dry, using Sap Green mixed with Burnt Sienna. They serve as a strong contrasting backdrop for the light rooftops.

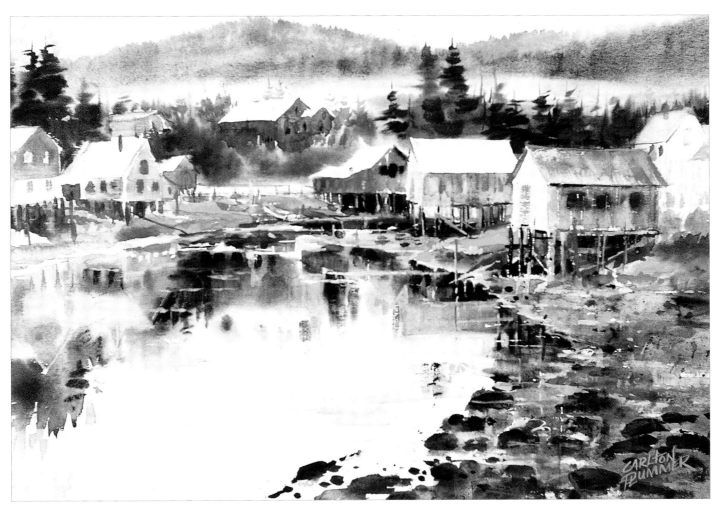

Art in the making Combining techniques

With a rather complex subject such as this one, I generally like to use a variety of application techniques. I feel this adds to the visual interest while expressing my point of view. The techniques used in this painting include wet-on-wet washes, wet-on-dry washes, glazing and drybrushing.

1 Establishing the structure
Using a combination of both wet-into-wet and wet-on-dry techniques, I began by establishing the general color tones and design structure. I used a broad flat brush for the sky washes, then switched to a large round for better control in the wet-on-dry middle ground and foreground.

2 Defining a diffused silhouette
After finishing the large, light washes and allowing them to dry completely, I came back in with a rather strong, well-defined cool silhouette against the misty sky and water. This gave the shape a crisp edge. But within the silhouette, a wet-into-wet application allowed the blues and dull greens to mix into a soft, diffused pattern.

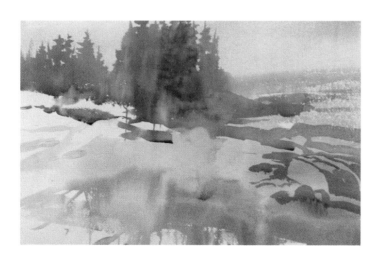

3 Building shape and volume
By glazing in some gray-blues with a large round brush, I began to tie the background silhouette to the foreground. I kept these layers simplified and fresh, building up shape and volume without a lot of detail to delineate the rock forms.

4 Uniting the painting with glazing
I continued this same process in the left foreground, building up more mid-values to suggest form, light, depth, color and mood. Repeating the same colors used earlier added to the cohesiveness of the design. Notice how I laid in both broad passages and finer lines all with the same round brush.

"Although it's possible to be creative without clever techniques, or to be accomplished in your handling of a medium without being particularly creative, the ideal is to have a balanced blend of both."

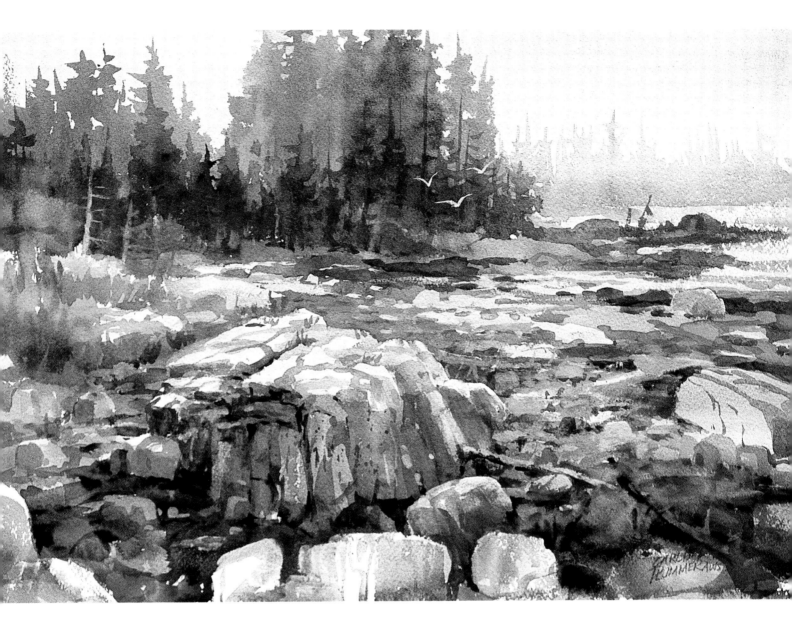

5 Finishing with texture

With the mood of the painting established through a fairly broad value range of warm and cool colors, I proceeded to place the deepest colors, striving for clear, luminous darks so as to retain the feeling of sunlight in "Ocean Island" (11 x 15" or 28 x 38cm). I used drybrushing in the distant water and foreground rocks (sometimes just along the edges of glazes) to suggest some texture in each of these elements.

→ with the paint. You can minimize your mistake by wetting the too-dark area, applying pressure with a damp brush and lifting off the paint. A chisel-shaped brush is best for large areas, but a flat tool with an edge, such as a knife or the handle end of a brush, will lift off more paint, creating a lighter and sharper area.

It's best to make corrections when the surface is damp or dry. If the paper and pigment are too wet, the paint will run back in. Just go slowly and proceed cautiously, otherwise you risk damaging the surface of the paper. Some papers are more amenable to this technique than others, and experimentation will reveal that information.

Once you have mastered these wet-on-dry and wet-into-wet techniques, you can start to combine them, as I do. You'll find that incorporating a variety of techniques will add visual interest to any painting.

Here's a detail of a painting where I sprinkled salt onto a damp, freshly painted area to create a crystallized pattern of lights on darks. Alternately I could have sprinkled clear water to generate blotches. Applying salt or dropping water onto a semi-wet or damp paint application are two more techniques for creating textural effects.

You can correct or modify an area by scraping or lifting off some pigment. Gently wet or dampen the area or line with clear water and a stiff brush or blunt edge, then use a tissue or paper towel to blot. If the paper gets too wet, however, the color will run back into the groove and turn dark.

East Boothbay Boatyard, 15 x 22" (38 x 56cm)

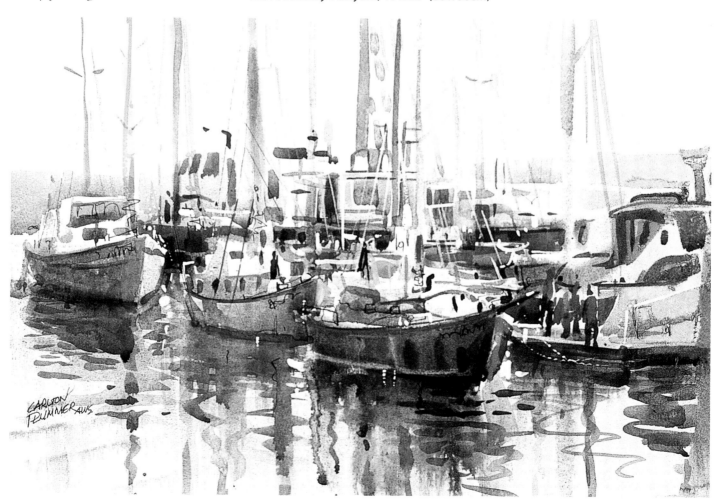

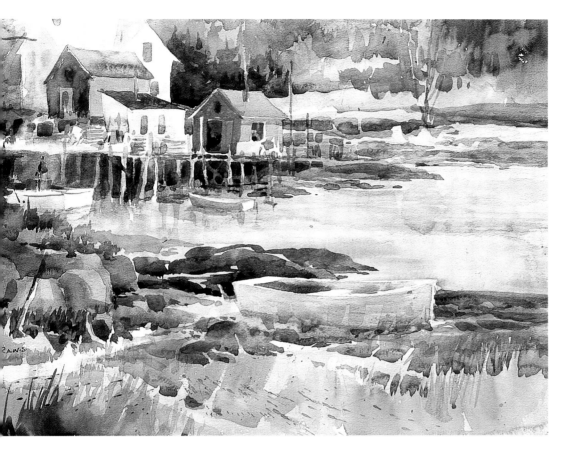

Cozy Harbor,
15 x 22" (38 x 56cm)
This demonstration piece, executed on location for my workshop students, shows how the dark shapes work to carve out the positive shapes, such as the boat and buildings. This was accomplished through glazing on dry paper with a flat brush to create crisp edges. I also carved around the driftwood with warm tones to suggest grass, leaving white paper exposed.

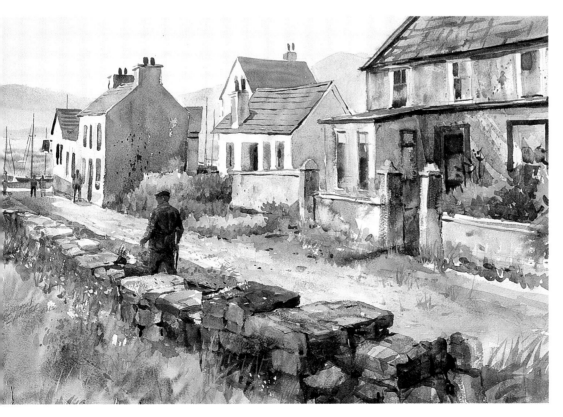

Ballydavid, Ireland,
15 x 22" (38 x 56cm)
For this painting, I used a 140lb cold-pressed paper to show some texture and to enable the interaction of the various warm and cool pigments. For example, notice how the wet-into-wet washes kept the sky clear and light, creating a good contrast to the richly colored rooftops. Later glazes also allowed some of the warm underneath color to show through. The dark silhouette of the walking figure tends to pull the various parts of the painting together.

Art in the making Washes and glazes

This demonstration proves that fancy techniques aren't a requirement in creating a great painting. Even a relative beginner can paint an exciting, interesting image like this one, using the most basic of techniques. It just takes a little practice.

1 Drawing with the brush
A pencil or charcoal drawing isn't needed to get started. I began with a simple drawing, using a large round brush and a light gray-blue tone. It was sheer delight to freely glide the loaded brush over the paper, focusing on sketching in the shapes without ever lifting up the brush. Notice how I alternated between using the brush's point and the side to vary the line widths in my drawing. This way of starting a painting always gets me very involved in my subject. I was hooked, eager to keep going.

2 Working wet
After spraying clean water over my surface to keep the painting wet and juicy, I began to lay in some warm tones wherever light was hitting the rocks. Because of the wetness of the pigments, the warms and cools intermingled, creating beautiful, unique colors.

▶

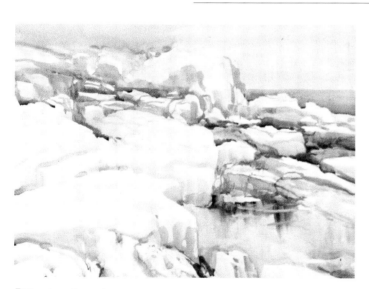

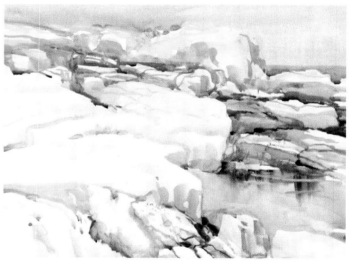

5 Varying the colors
As a contrast to the sky, I used a Cerulean Blue to put in the distant ocean. A wet-on-dry application created a nice, crisp edge along the horizon, just right for this sunny scene.

6 Using darker values
I then continued to develop the sides of the ledges to create depth. Wanting to continue the loose spontaneity of my initial washes, I wet the paper before applying more layers of wet, runny paint in middle and mid-dark values of the same colors previously used.

3 Creating wet-looking reflections
I continued developing the ledges by adding violet tones, creating variety in their sizes and making the large expanse of rock seem even larger. For the reflections of the rocks in the center tide pool, I painted wet-into-wet, stroking the mid-value pigment vertically through clean water, then going back over the wet strokes horizontally to suggest ripples in the pool. This also provided some variation in the application from the way I'd done the rock ledges. Next, I used a classic wet-into-wet wash to create a gradated sky.

4 Lifting out a too-dark dark
Notice how I allowed the pigment to "bead" along the bottom edge of the sky. I like to do this because it creates more variations in the value. After checking my progress at this point, I decided I needed to lift out some of the pigment in the tide pool. To do this, I used a stiff, clean brush loaded with water to soften and lift the dry pigment, which I then blotted with a tissue.

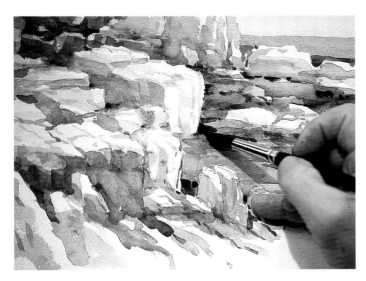

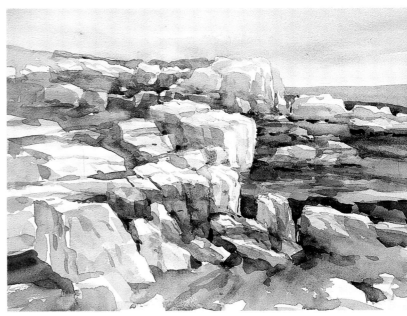

7 Accenting and glazing
Using deeper, darker accents of mauves and blues, I intensified areas around the rocks. To push some of the middle-ground rocks further back, I glazed a deeper value of red-violet mixed with Quinacridone Gold.

8 Unifying the design
In the final stage of "Rocks at Pemaquid Point" (11 x 15" or 28 x 38cm), I decided to expand the tide pool in order to create a larger shape that simplifies and unites the design. This is where glazing really comes in handy — it's ideal for unifying shapes. I then lifted out some highlights and added a few more dark accents of gray-blues and violets to make the rocks look more solid.

A painting utilizing all the basic techniques

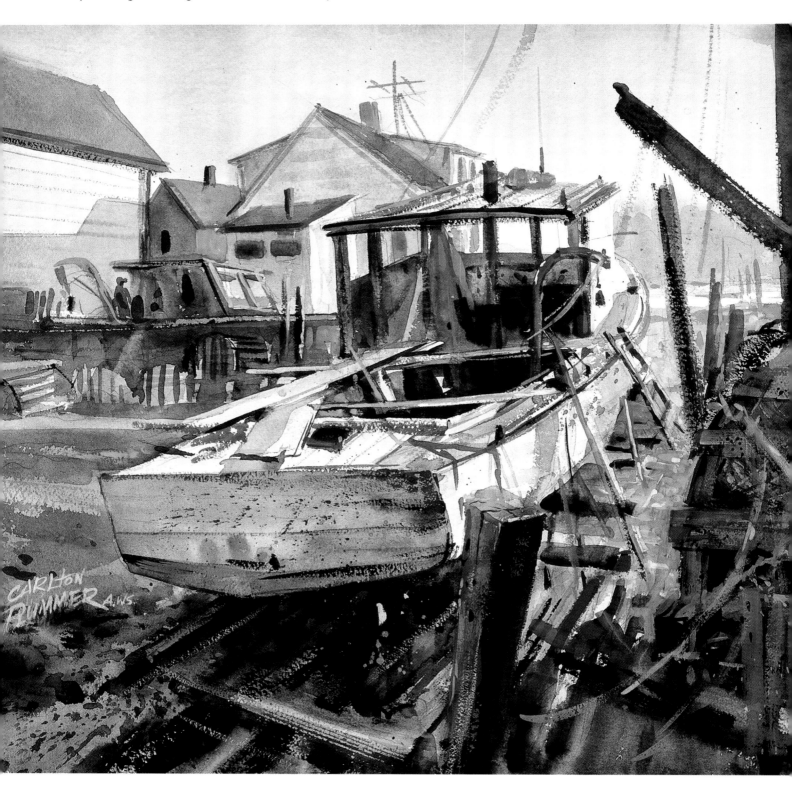

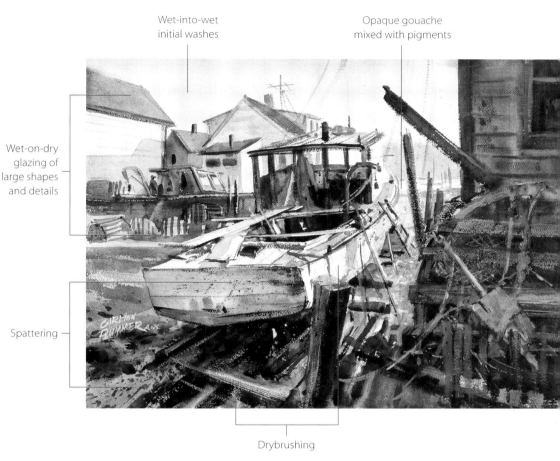

Wet-into-wet
initial washes

Opaque gouache
mixed with pigments

Wet-on-dry
glazing of
large shapes
and details

Spattering

Drybrushing

Port Clyde Sundown, **21 x 29" (54 x 74cm)**
I painted a small study of this boat on location, but conjured up the overall composition
and mood in the studio. As can be clearly seen in this monotone version of the painting,
the strong light and shadow on the stern of this old lobster boat became the focal point.
 Diagonals made this composition work. The foreground diagonals of driftwood and
low tide elements lead the eye to the stern of the boat, while the building comes off the
left of the composition to tie in. A variety of painting techniques helped to unify this
complex subject.

"I feel that a wet-into-wet application is watercolor painting at its finest. It allows the pigments to flow and interact, creating diffused and unpredictable color — what excitement!"

Kenai Peninsula, Alaska,
15 x 22" (38 x 56cm)

I encountered this shack while exploring the wilderness of Alaska. It is side-lit but forms a silhouette against the water and sky. I worked on location with a limited palette, as value and texture were more important than color. This is why I turned to drybrushing and lots of glazing to capture the effect of a dull, overcast day.

Off Ocean Point, Maine,
22 x 30" (56 x 76cm)

Here, wet-into-wet washes helped to accentuate the movement of the water. For instance, warm, transparent washes made up of Raw Sienna, New Gamboge and Permanent Rose were brushed onto the damp surface and pushed upward to the wet-into-wet surf area, which acts as the impact area. A gray-blue wet-into-wet sky then met the white paper that represents the surf. Deeper tones were applied wet-on-dry as accents and shadows.

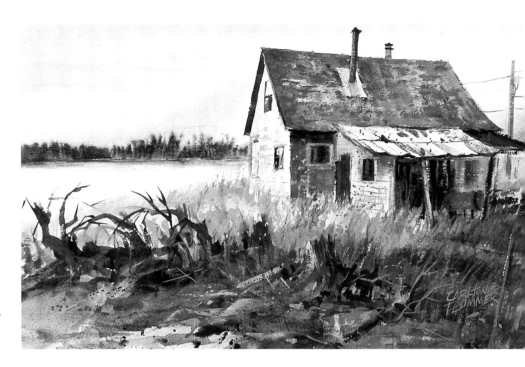

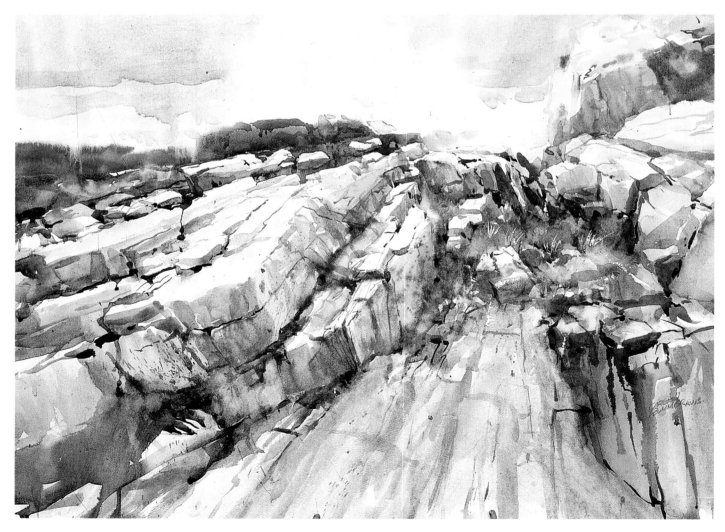

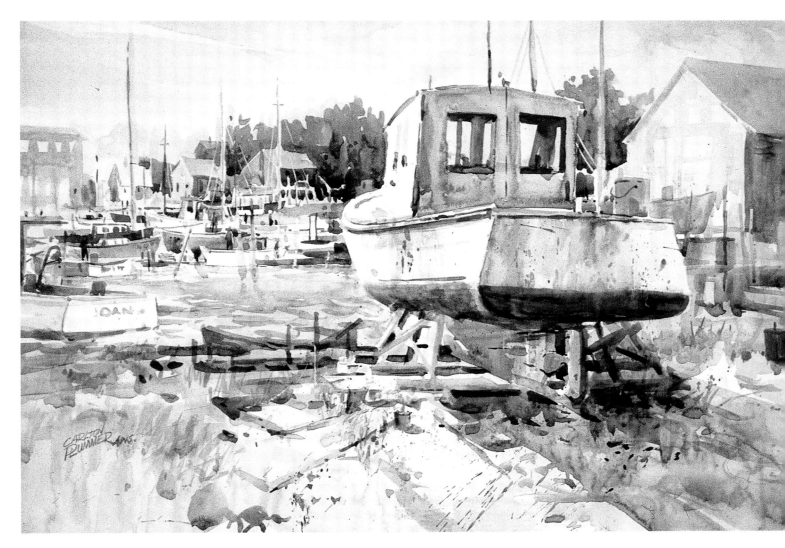

In For Repairs, 15 x 22" (38 x 56cm)

The lobster boat in the foreground occupies a large portion of the painting but leads us past it to an active area of boats. The dark shape placed at this point carves out the cabin and bow of the boat and acts as the background. The dark shapes under the boat and on the bottom of the hull, also achieved with glazing on dry paper, balance the composition.

Using opaque white gouache

Years ago, I was amazed to discover that John Singer Sargent — considered by many to be the best watercolorist in history — had used opaque white gouache to establish a contrasting tone on a figure against a dark mass! If it was good enough for him, then it is good enough for me.

Since then, I've found many methods of using gouache or opaque watercolor, and it has a permanent place in my watercolor paintings when I feel the time is right. With skillful mixing, I can mix opaque white with watercolor to create a light glaze. This is often the best, most effective way to extend an existing wash or to cover a dull, dark or muddy area. Opaque white, alone or mixed with watercolor, is also great for putting in accents and adding impact to an area.

A few minutes of mental and visual preparation before you get started will greatly increase your chances of creating a unique, interpretive painting.

Preparing to paint

If you're interested in capturing the drama and excitement of a marine landscape — or any landscape, for that matter — I cannot tell you just how important it is to paint on location. It may seem difficult or cumbersome, but outdoor painting is completely worth the effort. You'll find so much inspiration in the variety of lighting, angles, weather and cast shadows in the subjects you'll see. The clouds will move across the sky, people will arrive on the scene, the tide will come in or out and all of these changes will provide you with more options for making your painting as strong as it can be. And every bit of information you could possibly need to capture your subject will be right there, before your eyes. So if you've never tried working on site before, here's how to make the most of the experience.

Reaching your coastal subjects

No matter where you live, be it on a coast or even inland, you probably can get to some body of water — pond, river, lake or ocean. Sometimes getting to these areas is quite easy, involving a nice car trip and a short walk. But there are also times when getting to the remote areas can be a hassle and may require a small boat or canoe. Sometimes you may need to work your way over rough terrain or through thick undergrowth. Be prepared, and remember the effort is worth it.

It's most common to view a coastal or marine subject while standing on the shore, but at some point, you might want to try viewing the coastline from a boat, looking back toward shore. This presents a very different scenario, offering you new and exciting composition options. Painting from the boat is not something I recommend, but you can photograph your subject from there and then apply all of your creative resources to capturing your subject back in the studio.

Choosing a subject

When you first arrive, your time would be well spent walking around with your camera. Sometimes incredible lighting is happening right before your eyes, but it will change quickly and may not be that exciting again. A quick click of the camera will capture the qualities of that exact moment in time.

After exploring with your camera, snapping various lighting effects and points of view, your next step is to zero in on the subject you feel has the most potential to make a good painting. One quick way to help yourself make that decision is to look through a small viewfinder — a rectangular opening in a piece of mat board. Move the viewfinder up and down, vertically and horizontally, until you find something that looks like an interesting composition and perspective.

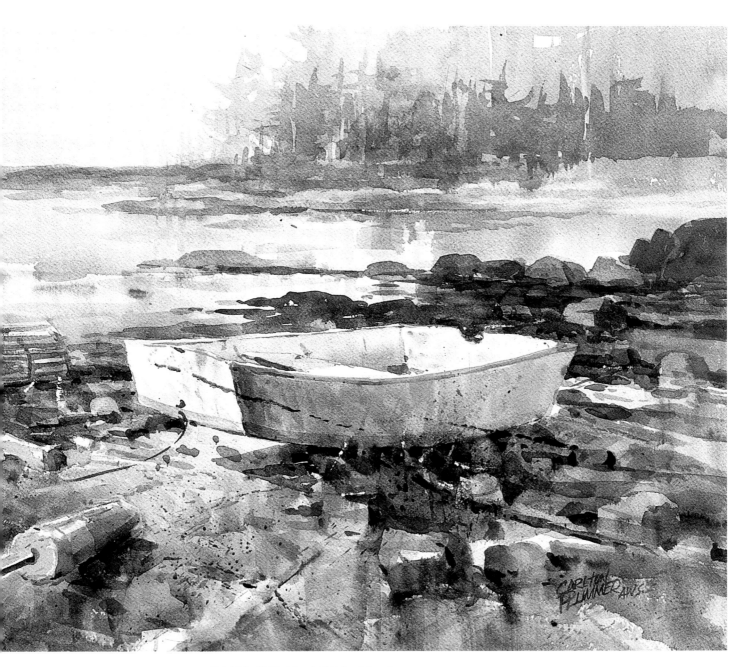

Ebb Tide Skiff, 15 x 21" (38 x 54cm)

While demonstrating on location for my workshop students, I wanted to explain the importance of dramatizing an ordinary scene by emphasizing darks and lights and spotlighting an object such as this skiff in the low tide mud. I made a quick line drawing first to confirm the directional angles of my composition. I then added a few light and dark values to my cartoon to determine how best to support the boat. Making these decisions up front in my cartoon/value sketch helped me work more quickly and efficiently in establishing a serene mood with a glow.

"Some subjects lend themselves to a large, panoramic format, while others are best-suited to a smaller, close-up, more intimate view."

A compact camera is adequate for on-location photography. These photos, along with sketches and small paintings, will serve as research material gathered on location that can be used later on in the studio. Always be aware of the changing conditions and capture them quickly with your camera.

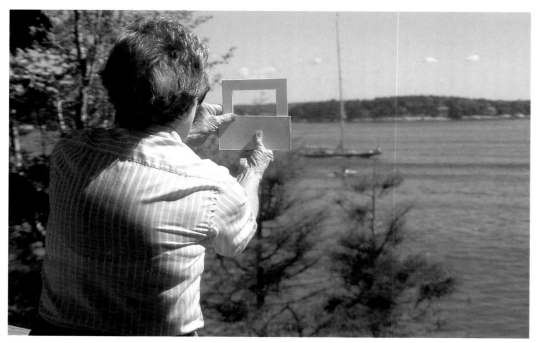

While walking around your painting area, look through a viewfinder to see the various options available for compositions. You can make one easily by cutting a rectangular (or square) window in a small scrap of mat board. The closer you hold it to your eyes, the wider the angle of vision. This is helpful in seeing how the shapes work within a restricted area vertically or horizontally.

Creating preliminary studies

As much as you may be tempted to "strike while the iron is hot" and jump right in to the painting process, I encourage you to take just 10 minutes or so to do some preliminary studies. Giving yourself time to make key decisions about your design and composition will save you a lot of frustration later on and will help to ensure you have a powerful, interesting painting at the end of your painting session. (Incidentally, these preliminary steps work well even when you are painting from photographs back in the studio.)

With your sketchpad in hand, begin by doing a series of small outline studies called "cartoons". First, break down what you are going to paint into 10 to 14 varying shapes. Study this design. Is it as interesting as it could be? Perhaps not. So spend a few more minutes drawing several more cartoons in which you explore a variety of compositional options.

Deciding on a point of view

As you draw your cartoons, you should be trying to answer some important questions that will give your painting a unique point of view. For instance, how large should the painting be? Some subjects lend themselves to a large, panoramic format, while others are best suited to a smaller, close-up, more intimate view. Should it be a vertical or horizontal composition? A landscape doesn't have to be horizontal. What seems to be a horizontal scene at first may, with some rearranging, turn into an exciting vertical.

How about the cropping, or how closely you zoom in on the subject? Sometimes it's very interesting to get closer to a subject, but then again, sometimes it's interesting to position your main subject in the distance so the viewer has to look beyond something large or in between shapes, such as trees or boats, to get to the heart of the painting. That can reinforce the feeling of depth and add variety to the shapes.

Now think about the placement of the horizon line. An exaggeration of the horizon line — high or low — can add drama to the situation. A lot depends on what you have as subject matter and how you want to present it. For example, if the foreground and middle ground are loaded with activity, perhaps more space should be devoted to them, resulting in less sky.

Plotting your tonal values

As you practice doing these "cartoons" — and as you study the design principles in Chapter 5 — you'll find it will get easier and easier, requiring only a few minutes to arrive at a good, solid design. You could move ahead to the painting at this point, but I recommend doing just a little bit more planning in the form of a thumbnail tonal sketch.

I always feel that a painter should design a painting with at least four to five values from light to dark. Although it is not necessary to use a full range of values, the bigger the variety,

Before you start painting the subject you've chosen, I recommend using your sketchpad and a pen or pencil to do a series of small outline studies called "cartoons".

First, break down what you are going to paint into 10 to 14 varying shapes. Then draw several more cartoons in which you explore a variety of compositional options, such as a different viewpoint, angle, cropping, position of horizon line and so on.

" First, break down what you are going to paint into 10 to 14 varying shapes."

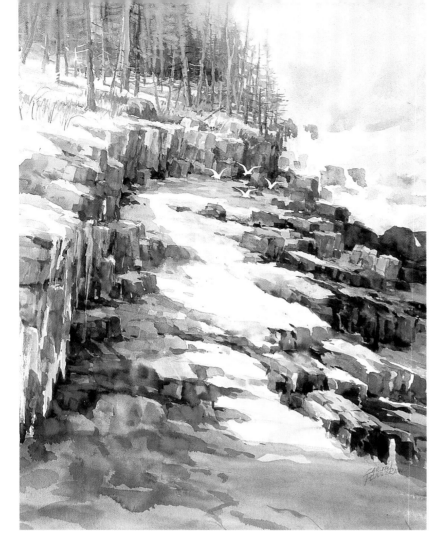

the more you will retain the interest of the viewer. Generally speaking, you'll want to put the greatest contrast of tonal values in and around your focal area.

The perfect time to make these decisions is, again, in a quick, preliminary sketch done before you start in on the actual painting. Together, your cartoon and value sketch will provide you with a roadmap to reaching your destination, an expressive and well-designed painting.

Thinking about expression

In this entire discussion about preliminary work, there hasn't been a word about color — and that's for good reason. Without a strong composition and a well ➔

Winter Surf #1, 30 x 20" (76 x 51cm) and ***Winter Surf #2, 20 x 30" (51 x 76cm)***
One of the questions that arises with every new painting regards the format — vertical or horizontal? You may have preconceived ideas about this so never forget you can invent and rearrange to suit your needs, as I did in these two paintings of the same subject. This happens to be the view of my front yard by the sea in Boothbay, Maine, which I have painted many times in a variety of moods.

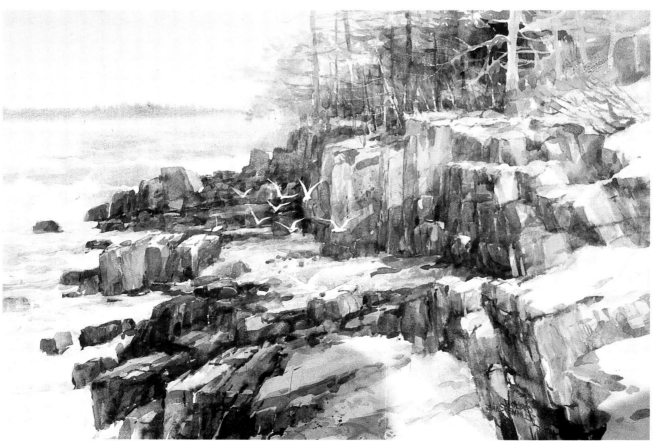

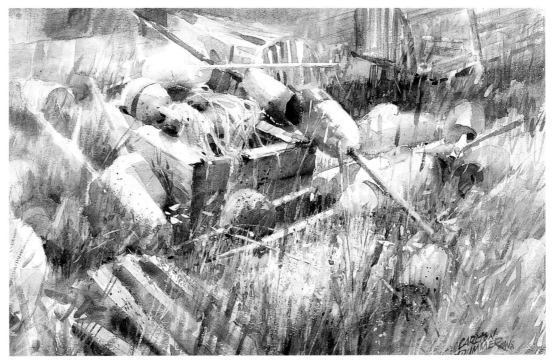

Island Still Life,
22 x 30" (56 x 76cm)
Using a viewfinder helped me to find the perfect cropping for this painting. It presents a close-up view of these objects, which is a compositional device that I think adds a lot of drama. I liked the way the shapes of the lobster traps connected to provide a flow-through shape, all of which is enhanced by a very natural focal area in the buoys and other gear.

Sketching from life

Drawing is a valuable skill that can be learned, and it will definitely facilitate your painting. Even if you decide not to paint the subjects you draw, it is still very satisfying to sit down on location and capture the scene in line and tone, especially when you are touring a beautiful area far from home. Drawing makes you focus in on important information, and it allows you to retain that information longer than if you simply photographed your subject. So always have a sketchbook handy. You will learn to draw faster and discover a shorthand method that will enable you to record your visual experiences.

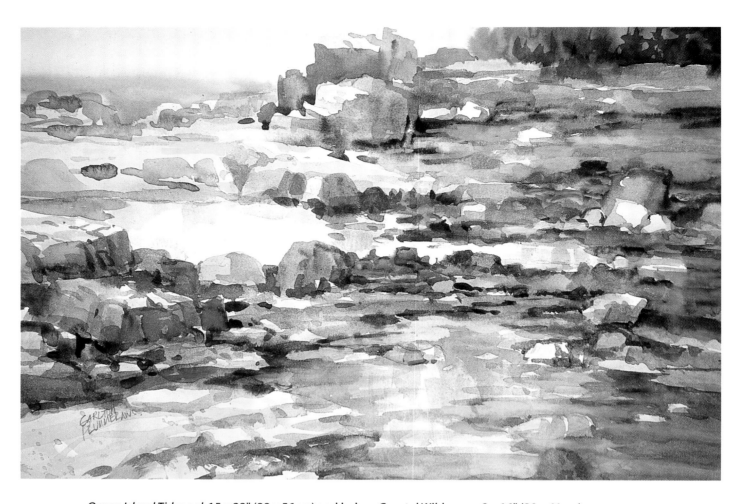

Ocean Island Tidepool, 15 x 22" (38 x 56cm) and below, *Coastal Wilderness*, 8 x 16" (20 x 41cm)

Study these two paintings. To realize all of your design options, you'll need to get down low and up high, changing the horizon line in the process. A lot depends on what you have as subject matter and how you want to present it. If the foreground and middle ground are loaded with information, perhaps more space should be devoted to it, resulting in less sky. (Incidentally, "Coastal Wilderness" is also a great example of an elongated format, another option for making a composition more interesting.)

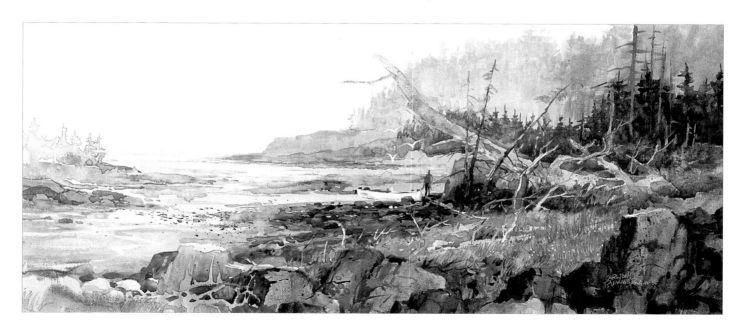

Art in the making Mental and visual preparation

It's amazing how a few minutes of mental and visual preparation up front, before putting brush to paper, can make the entire process so much easier and effective. Follow along with this demo, done before a class of students on a misty day in Cozy Harbor, Maine, to discover how my preliminary efforts helped to ensure a successful end result.

1 Mapping out my design
To save myself a lot of time and frustration later on, I began by drawing several variations of my cartoon. In each one, I considered different possibilities for where to place the horizon line and how to organize the shapes into a dramatic design. After just a few minutes of sketching, I settled on this composition, although I knew I could and might adjust it slightly as I continued on. I then thought about such factors as mood and lighting. Because of the lack of strong sunlight, I felt the essence of an eerie light creating a sense of space.

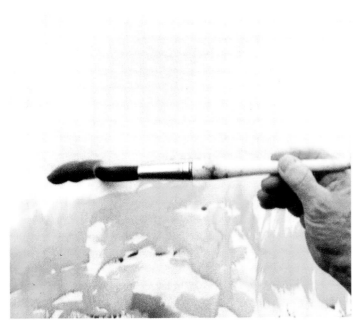

2 Linking with wet washes
With my concept now clear in my mind, I was ready to get started. After wetting my paper, I laid in a series of light washes to define the biggest shapes in my image. I wanted these foreground washes to lead into a series of distant silhouettes that would evoke the misty, eerie mood and space I was after. The first silhouette on the left was painted wet-into-wet in a warm, neutral tone that would link the grassy area to the far island.

3 Creating a distant silhouette
After re-wetting my sky area, I applied a much lighter blue-gray mixture of Raw Sienna and Ultramarine Blue to create the silhouetted island of trees in the distant background.

▶

4 Making reflections

Still working on a very wet surface, I extended the silhouette across the background, varying the temperature of the blue-gray mixture and allowing it to connect with the linking shape on the left. To enhance the continuity of this area, I brought the same pigments used in the silhouette right down into the water to suggest soft reflections. Notice how I improved on the balance in my initial cartoon's design by moving that small distant island more to the left.

5 Re-stating the rocks

Once I had allowed my first light-valued washes to dry, it was time to go back in and make a stronger statement with mid-values. Quinacridone Gold and Ultramarine Blue provided just the neutral I wanted to put over the rocks as a lead into my composition.

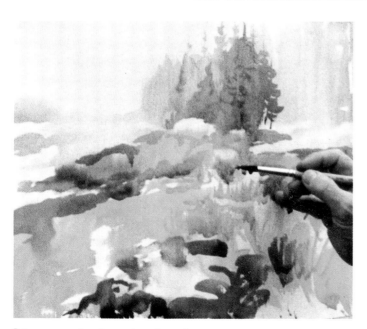

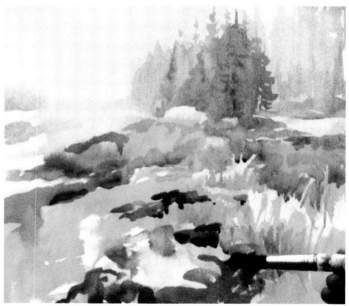

8 Incorporating loose brushwork

Following my tried-and-true adage of "same value, different colors", I added variations of greens to the tree mass and throughout the foreground grasses to connect the major shapes. This loose brushwork, not overly detailed in nature, provided a hint of definition, texture and interest for the eye without breaking up the big shapes into too many little, contrasting areas that would detract from the misty mood.

9 Accentuating the foreground

Now it was time for some dark accents in the closer grass area and on the large rocks. Alizarin Crimson mixed with Prussian Blue gave me just the value to get the job done. Leaving the more distant grassy area simplified added to the illusion of receding space.

6 Connecting with color

As I continued to glaze on more colors, I tried to establish a series of planes along shifting diagonal lines that would move your eye back into the composition, from the foreground rocks containing the tide pool, to the grasses, then into the water and finally to the misty silhouette and sky in the background. By working in one continuous, overlapping application, I was able to relate these glazed shapes to one another in a harmonious flow, yet still provide variation in color, value and edges.

7 Glazing greens

Next, I began to glaze a mid-dark value of green over the seaweed on the right to help your eye connect the major planes.

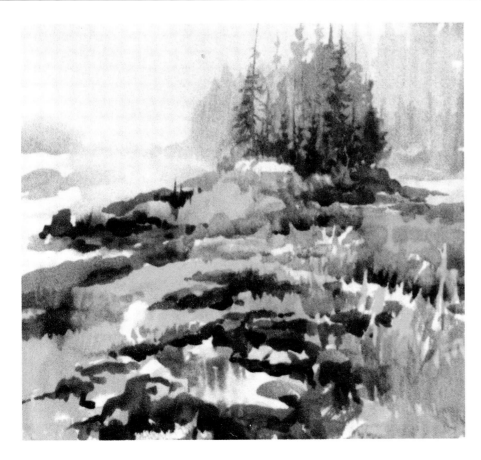

10 Pulling things together

To complete "Cozy Harbor Mist" (15 x 22" or 38 x 56cm), I softened edges, glazed over the foreground grass and added the reflections wet-into-wet in the small tide pool. A few slightly darker trees on the island added more depth and enhanced that focal area.

Turning point —
How I learned to see tonal values

Our painting careers are laced with breakthroughs. I found I had problems with painting rocks in the sun because there was so little differentiation in the values, plus the light source was constantly changing. When I switched to painting interiors, it became easier to see and understand subtle value relationships within a narrow range of values. After a season of painting interiors, I returned to the ledges reinforced with a richer command of values.

→ thought-out design, color will be ineffective. Only when you have your composition nailed down in your sketches should you begin to think about color and how it will affect the mood of your work. Is it a happy, sunny mood you're after, or a somber, melancholy look you want? How can you express that through color? Remember, color is just one of the many factors you can use to dramatize your emotional response to your subject, so I'll be covering it in greater detail in Chapter 5.

Tonal value study

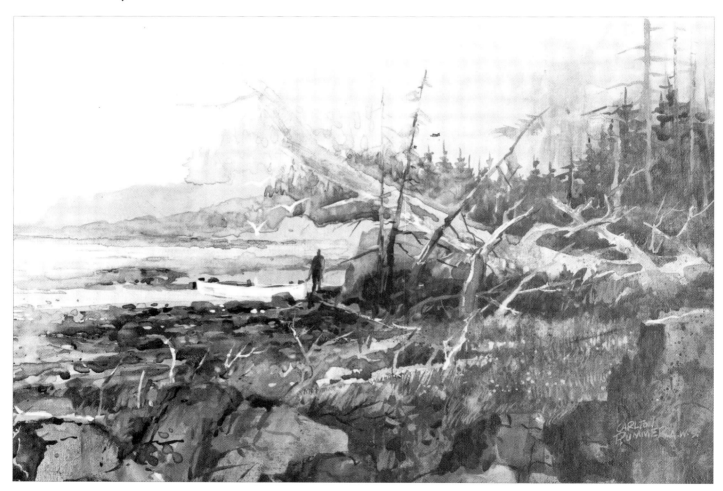

Anything you can do to eliminate constant changes and corrections during the painting process is a help, as it prevents you from building up muddy color and losing the luminosity of the paper. This is why tonal value studies such as these are beneficial in preparing for a finished painting — they give you a chance to work out the pattern of values in your composition before you start painting. Your value pattern can not only set a mood, it can also tie the whole work together. Consider using a soft 6B pencil, compressed charcoal or paint (Lamp Black watercolor and white designer's gouache) as materials for creating value studies.

For right now, just focus on preparing yourself to paint. This entire preliminary process only takes a few minutes, and it's well worth it. The planning stage is the ideal time to ask yourself what is the most advantageous approach to expressing and communicating your feelings about this scene. Usually, you will need to call upon your inventiveness and imagination in order to enhance the drama and mystery, so recording your ideas and options in sketches becomes even more essential.

As I continually say to my students, "Keep your options open". This is your painting, your choice to do and express what you feel strongly about. Use the scene in front of you instead of copying it. It is your interpretation that makes it a unique painting. You can rise above a storytelling representation if you focus more on how the scene makes you feel. After all, creating a work of art is more important than the subject matter that inspired it.

And one more thing, be ready to take a chance. Playing it safe is too easy. As they say, "Nothing ventured, nothing gained". You must believe in yourself. Many times I have gambled and discovered something new. The ordinary became the unusual. Perhaps this is why I urge students to paint small and fast, then move on. Now you are ready to use the interesting techniques we covered in Chapter 2.

Tonal value study

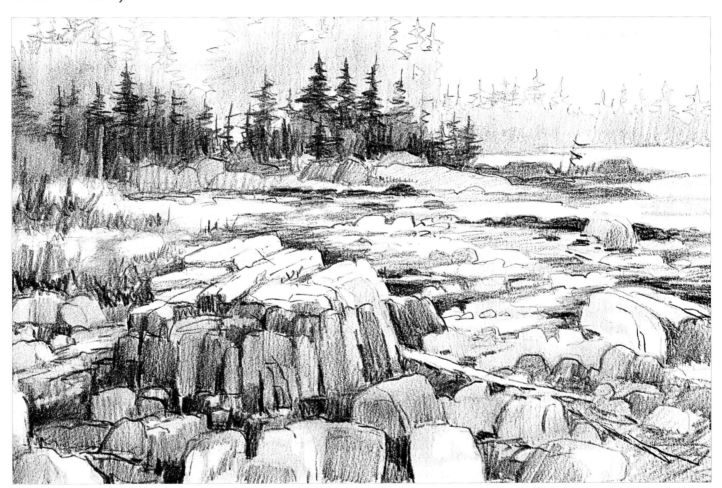

"Without a strong composition and a well thought-out design, color will be ineffective.'

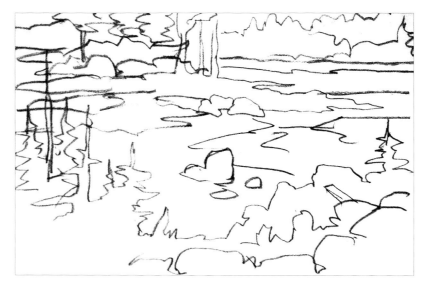

Knickercane Island, 15 x 22" (38 x 56cm)
This preliminary cartoon for the painting shows how
I initially broke down the image into about 14 shapes. In
the process, I decided where to position the horizon line
and where to position shapes so that they would lead your
eye into the painting. Notice how I simplified some shapes
around the perimeter of the painting. These areas should
have less action and variation, again to push your eye into
the center of the work.

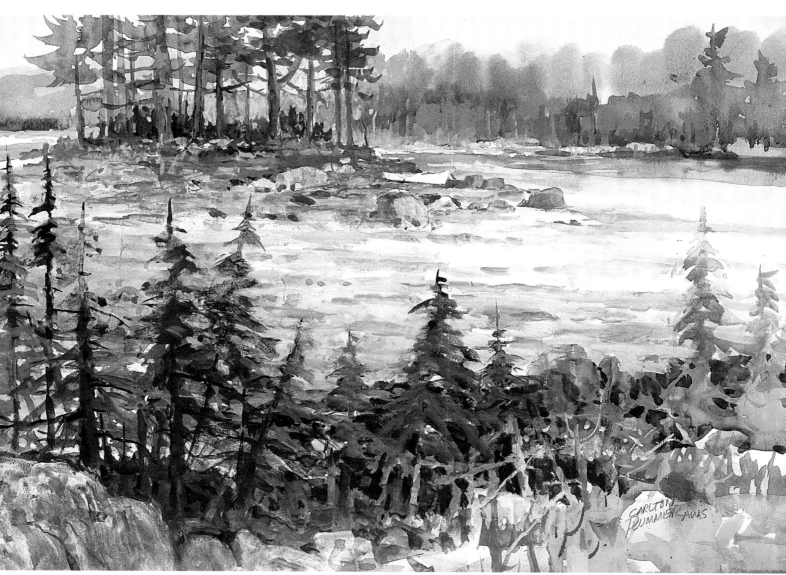

**Wharf Silhouette,
22 x 30" (56 x 76cm)**
Allowing the viewer to peer through the silhouetted wharf adds depth, mystery and drama as the lazy zig-zag tidal water leads us back to other silhouettes beyond. The flow-through water shape also helps to modify and balance the rigidity of the vertical/horizontal shapes. Without making these design decisions in my planning stage, this composition would fall into the category of the ordinary. But this allows us to move around and enjoy the overall mood of the day.

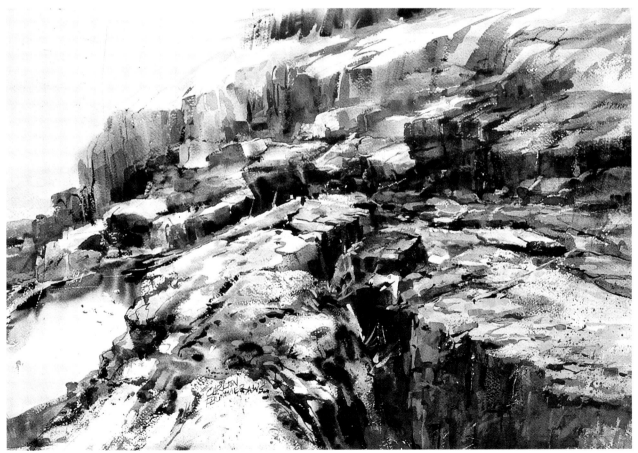

Ledge Maze, 21 x 28" (54 x 71cm)
Although I painted it on location, most of it came from imagination fired by emotion. I was after a close-in view that was indicative of the ruggedness of the Maine ledges. A cartoon to determine the most effective point of view, followed by a small tonal study, allowed me to capture the directional thrust that was so crucial to this design.

"Giving yourself time to make key decisions about your design and composition will save you a lot of frustration later on and will help to ensure you have a powerful, interesting painting at the end of your painting session."

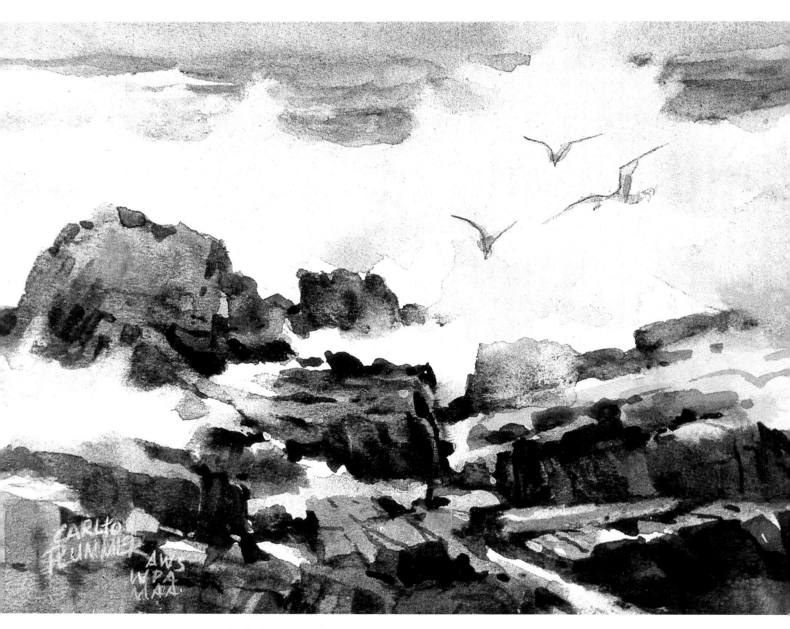

Surf Glow, 15 x 22" (38 x 56cm)
While on location, I sat and studied the wave action and the light and dark patterns as they appeared and disappeared continually before my eyes. Then I made several quick tonal studies to help define the action and the basic composition. While painting this piece, I blocked in the water shapes, leaving a white area that I felt would be my impact area. By referring to my studies, I was then better able to put in the dark rock masses over the light areas of water.

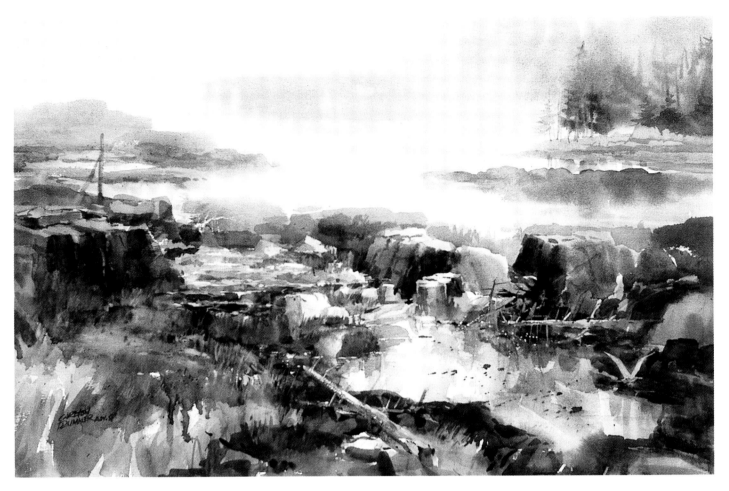

Inlet Mist, 22 x 30" (56 x 76cm)
Right from the start, I knew I wanted to capture the mysterious, atmospheric fog of this scene. So before I started painting, I determined which technique would work best for accomplishing the moody effect I intended. I decided to use a wet-into-wet approach for the silhouettes, land masses and reflections, and later glazes for the shapes and accents that needed sharper edges.

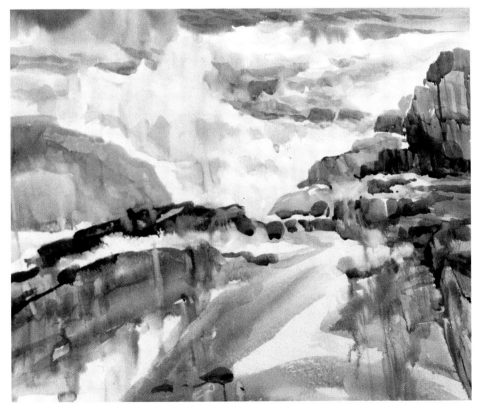

So much planning goes into my process before I start in on the initial washes shown here. Even at this early stage, I've already carefully planned out my composition in my cartoon and considered how I will use lighting and color to express the mood.

Are you ready to get started? I recommend you develop your approach to painting by following these steps in a series of quick, small paintings.

Establishing a painting process

No two subjects are exactly alike so each painting has to be approached in a slightly different manner. However, you'll find that over time you will develop a fairly consistent means of creating a painting. The following describes the method I generally use, so please consider giving it a try. As you mature as an artist, you can always modify your approach to suit your personality, style and subject matter.

Another reason your approach needs to be flexible is that things are constantly changing. When you're working on location, the light, the weather and the tide are in a state of flux. And then there are the unforeseen interactions and diffusions of paint on paper that will appear and disappear right before your eyes. You can take advantage of these unexpected flashes of inspiration by learning to adapt to a new direction as you go along. Freshness and spontaneity will help you create a beautiful surface.

For relatively new painters, especially working on location, I recommend developing your painting process by practicing on a small format and moving on quickly, capturing as many different happenings as possible while you have the best light. I feel it's best to reserve the full sheets for working in the studio, where you will have the comforts and

set-up for better control. But whether I'm on site or in the studio, here's how I generally approach a painting.

Laying out the big shapes
Assuming that I have decided on the point of view, done a quick study or two to confirm my composition, psyched myself into feeling the mood and developed a vague plan of attack, I am ready for action.

With a large, pointed brush, I dip into a watered-down combination of blue and either Raw Sienna or Burnt Sienna. With the brush, I proceed to draw in the large, flowing rhythms and shapes. I am always aware that too much detail can cause distraction and confusion, so I put in only the abstract structure of the large shapes, eliminating any unnecessary details that may deter from the main thought.

Some artists find it difficult to draw directly with a brush and prefer to draw in the basic shapes very lightly with a pencil. This is okay to do, but I find it easier to slide right into a painting without having an involved pencil drawing. Pencil lines always make me feel like I have to be careful, whereas drawing with the brush allows me to be free and strike quickly before I lose the light.

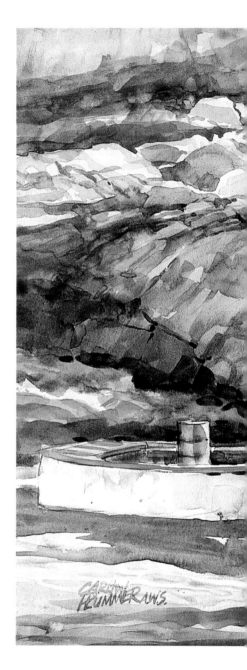

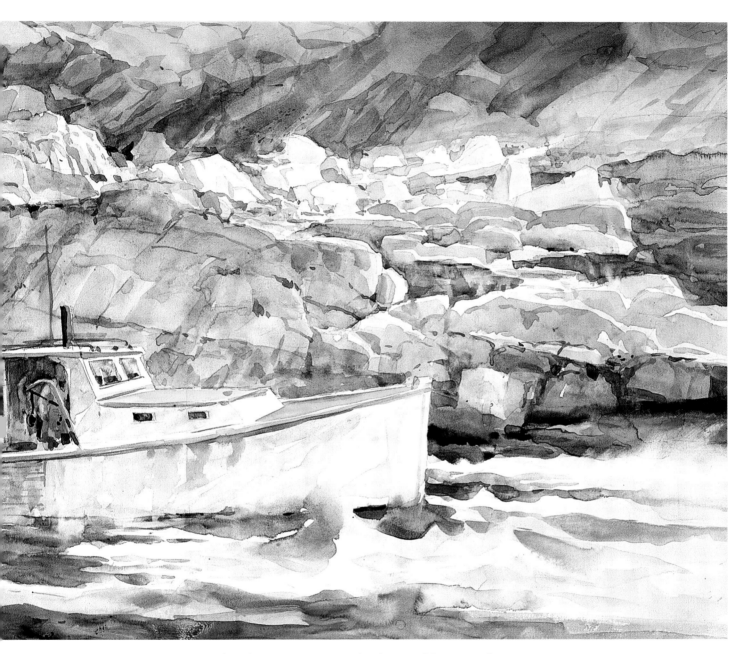

Lobstering on Outer Heron Island, **22 x 28" (56 x 71cm)**

For this painting, I set a goal to create a large backdrop of ledge for the lobster boat.
My plan was to divide the composition into two-thirds backdrop and one-third boat
and water. The ledge area would then be subdivided into one-third light shapes and
two-thirds dark shapes. Having this plan in my mind from the very start allowed me
to lay in all of my light areas in a few cohesive washes, and then to come back in with
darker shapes of repeated colors that further tied the painting together. Because of
the plan, I was able to make the water, boat and ledge unite as one.

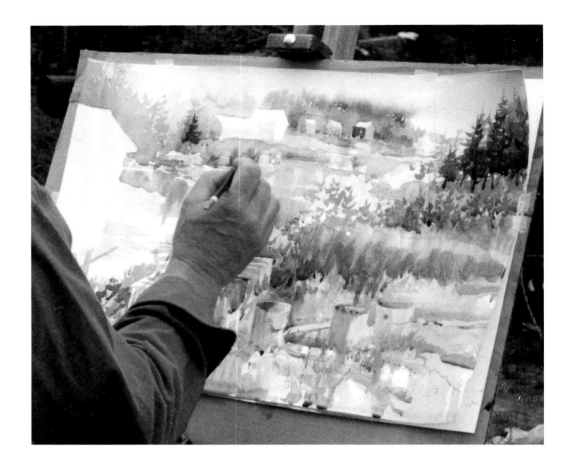

When I have areas that I want to keep white or very light in value, I use a wet-on-dry application technique in my initial washes so that I control the flow of the paint as I work around these reserved areas. This means I can avoid using masking fluid, which often leaves an edge that is too harsh or crisp.

Art in the making The light-to-dark process simplified

This short demonstration encapsulates my general painting process as I work from lights to mid-values to darks and then complete the painting with a few finishing touches.

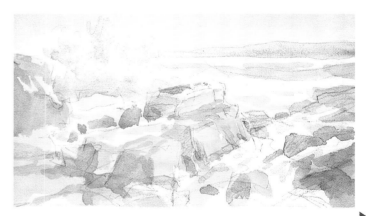

1 Using complements for dramatic light

Knowing that I wanted to create a feeling of late afternoon sun, I began the painting with light, wet-into-wet washes of pale yellow all along the sunlit sides of the ledges. I worked around the foam and water areas, leaving that white paper untouched. When that had dried, I used a complementary wash of cool violet in all of the shadowed areas and in the far distance. I extended that into a light blue wash in the crashing wave.

Notice that I had sketched in a few pencil lines but that I did not follow them meticulously. In my opinion, a sketch should serve as a rough guideline, not an outline to be filled in with color.

Applying light washes

More often than not, it's the sky that dictates the coloring and lighting that prevails in a painting, which in turn generates the mood. This is why I often begin laying in light washes of color in the sky area. I typically block in the sky with a two-inch flat wash brush with a light tint of a color that represents the mood of the moment.

I then continue laying in the light values of the major shapes, simply working around any areas I want to remain white. Applied both wet-into-wet and wet-on-dry, these light washes tend to soften the lines of my initial drawing, pulling them into tones. The mood that I am trying to portray dictates the temperature (warm or cool) that will dominate the painting. (However, the dominant warm or cool has to be balanced with the introduction of some colors in the opposite temperature during later stages.)

At this point, I am not completely committed to edges and definite shapes. I am trying to keep my options open and use the abstractness to my advantage. I will always be looking for interesting happenings along the way and continue to make adjustments with shapes and color.

Introducing mid-tone values

Once the light areas are applied, I begin to work on the lighter middle tones, trying to retain my whites as long as I can. It's easier to turn undefined light areas into objects than the other way around.

With the addition of the middle tones and middle-darks, I start to make a commitment in regards to more definite shapes that begin to reveal the true nature of the design. This is a crucial time in the painting that will take all the attention I have to offer. The middle tones play an important role in holding the painting together. I must incorporate a variety of middle tones between light and dark, otherwise shapes and lines will jump off the paper because there is too much contrast.

Many times, I also use middle tones to link several large areas together to form a flow-through shape that unites and solidifies the entire painting (explained in more detail in Chapter 5). Or sometimes the white passages in the water form a rhythmic flow-through pattern when linked together. Enhancing flow-through shapes with middle values is an ideal way to unify a fragmented design.

Carving out important areas

Once I have applied a couple of middle values, I begin to think more about where I want my points of emphasis and main focal area. Of course, these can change somewhat as the painting proceeds. Perhaps a little more value again, light at this point, will draw attention to various areas. Interlocking shapes that create pockets of excitement help to make the design more alive. Contrast of value and color are other key tools for drawing attention to my focal areas.

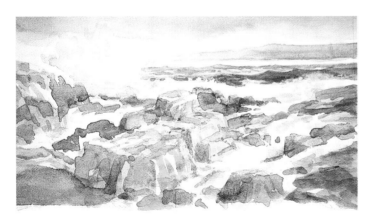

2 Defining with value
Using various combinations of these same harmonious colors, I went back in with mid-value and middle-dark value glazes to define the rocks and water and to dramatize the sunlight and surf.

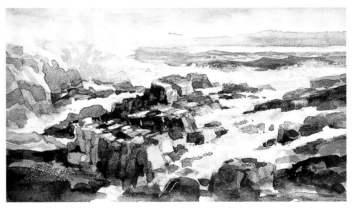

3 Accentuating the lights
Wherever I wanted to emphasize the highlights in "Surf Light" (11 x 15" or 28 x 38cm), I added dark accents next to them. The contrast in value tends to make the lights look lighter. I also softened a few edges with clean water, and put in the white foam with opaque white gouache.

"Too much over-painting or too many adjustments can destroy the freshness in a watercolor painting, and the true beauty of this medium is its bright, clean, fresh color."

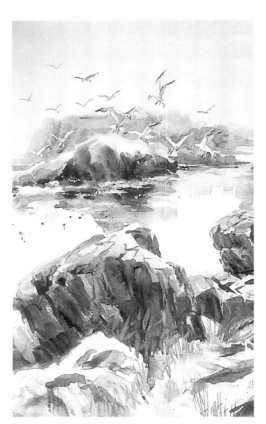

Island Skiff, 5 x 3½" (13 x 9cm)
One of the challenges of painting a landscape in a vertical format is relating the sky area with the land mass, generally because they are dramatically different in value and color. One thing I did to overcome that problem here was to repeat glazes of the same colors in the driftwood, rocks and seaweed. Repetition often helps to create cohesion.

Seward, Alaska, 11 x 15" (28 x 38cm)
I painted this on location in between rain showers, trying to capture the light as it broke through the gray clouds to reveal dramatic mountains. The boats, grouped closely together, were suggested with quick brush strokes that give the feeling of many masses. I used a large brush to block in the dark silhouettes of the mountains, but left the sky and waterway light to provide contrast and create the feeling of light.

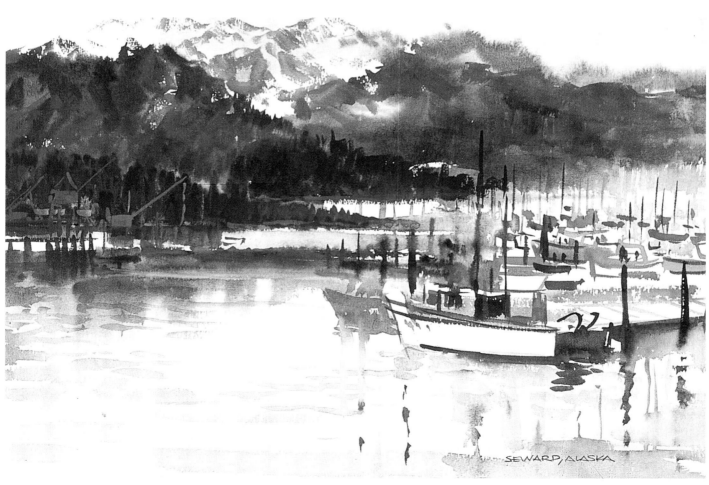

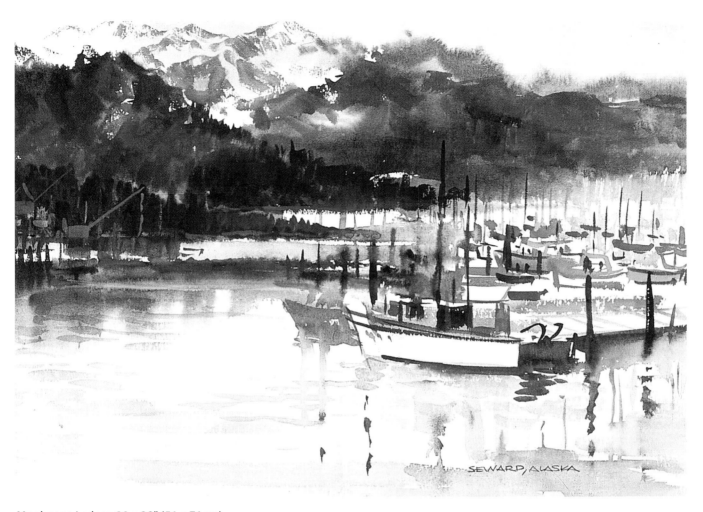

Monhegan Ledges, 20 x 28" (51 x 71cm)
When I painted this, I left the left-hand corner empty. Months later I decided that the eye level should be lowered so I could place a tide pool in this area. Because I keep my initial stages so loose, I am able to make these kinds of changes, even halfway through a painting. The late addition of the tide pool worked as a balance for the strong vertical ledge going off the paper. The gulls in the mist put the finishing touches to a strong statement.

Pulling the painting together

If I have designed my painting well and effectively worked light to dark, I will often need only a few very dark accents to provide finishing touches of crisp contrast that guide the eye around the painting. Actually, the painting might be considered finished without the extreme darks and accents. For example, if my scene involves an overcast day or a softer overall feeling to the mood, I may not need any more dark accents.

Of course, it is quite satisfying to see these well-planned darks and accents go into place. This is the moment I always wait for, when the painting is "singing!" Or is it? At this point, I like to carry the painting out of the direct sunlight and take a few minutes to evaluate my work.

First, I look at the overall value pattern and make sure my design is holding together well, the way I had planned it in my preliminary sketches. If not, I may need a few additional shapes or glazes to tie things together. A certain color may need to be repeated or echoed to help the cohesiveness of the design or to enhance the mood of my subject. There might also be some distracting shapes, areas or edges that must be softened or knocked back. And finally, the area of emphasis might need to be reinforced by lifting out some highlights, accentuating an edge or adding a bright or dark accent.

I must emphasize, however, that I'm very selective about the changes I make. Too much over-painting or too many adjustments can destroy the freshness in a watercolor painting, and the true beauty of this medium is its bright, clean, fresh color. This is why I refrain from making unnecessary additions and make only those that contribute to the image's unity and mood.

Checking for personalized expression

The act of painting is the summation of your ability to soak up or absorb visual information gathered on location and the partial digesting of this material. It is the outcome of all that proceeded. ➔

Art in the making A closer look at the process

Now let's examine how my painting process can be applied to a more complex, colorful subject. What attracted me to this subject initially was the exciting, low backlight behind a point of ledge and trees on Knickercane Island. As always, I sketched out my design in the form of a cartoon. I then decided to include the light mist on this particular morning. Capturing both the backlighting and the mist was a challenge because they both quickly changed as the bright sun rose in the sky.

1 Putting in a cool mist of blue
Working on a wet surface so I would get soft edges, I quickly laid in a light blue wash over the sky and water. I left some foreground areas white so that I could later put in the rocks, grass and seaweed.

2 Achieving a velvet edge
Because I wanted to achieve a velvety soft edge along the treeline, I wet the sky area, loaded up my cat's tongue brush with plenty of juicy green and began to lay down this mass.

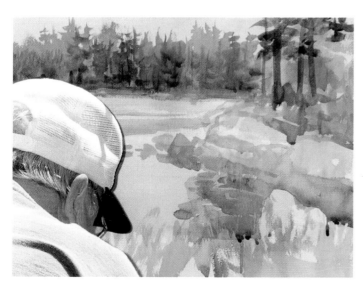

5 Defining a focal area
Next, I used wet-on-dry strokes to put in the mid-value reflections near the foreground rocks and then the vertical pine trees on the rock ledge. Because I wanted this to be a focal area, I added contrasting warm notes of darker reds and yellows to draw your attention there.

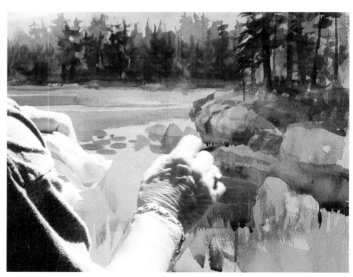

6 Adding shadows and darks
At this point, it was time for the darker values, such as the shadows on the undersides of the rocks and the foliage in the tall trees on the ledges.

3 Creating cohesion
I did not take my brush off the paper until I had moved all the way across in order to create a cohesive shape. Immediately after, I laid down a few horizontal strokes to create a land mass that would gently merge with the trees.

4 Formulating a plan
Before continuing, I decided how much warms and cools would be needed to balance the fairly cool tree area. With this in mind, I was able to efficiently achieve plenty of temperature variations in the mass of middle-light values of blues and greens laid down along the entire right edge of the painting. I used a combination of wet-into-wet and wet-on-dry here for additional variety. Determining what I wanted in advance meant I could accomplish it in one fresh pass, rather than having to layer on many colors and potentially lose the luminosity.

Since the tree mass in the background was still damp, I went back in to layer in some darker greens that would softly diffuse into the existing greens. See how some edges are very soft and some only semi-soft? This enhances that feeling of a misty morning, part of my original concept.

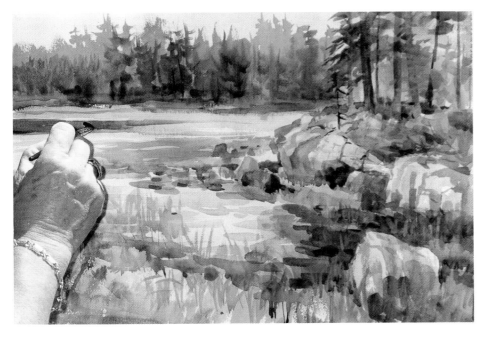

7 Finishing off by bringing out the lights
Still keeping in mind that my goal was to capture the early morning light and atmosphere, I put in several variations of yellow-green and warm green grasses in the foreground. The individual strokes contributed some texture and interest in this area. Due to their contrasting value, a few final touches of darks helped to bring out the light of "Early Light" (15 x 22" or 38 x 56cm).

Here's a middle stage

The middle stages of my painting process involve laying in glazes of middle and mid-dark values to better define my forms and also to create contrast in and around my focal areas, such as the fish house shown here.

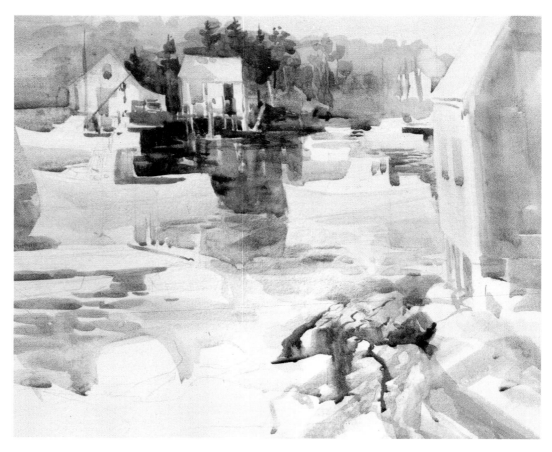

Here's a final stage

In the final stages of my process, I tend to work more slowly, carefully choosing where I will place dark accents and details within a painting. These need to be strategically placed so they lead your eye around the painting and to the focal area. This was a demo executed on Cadillac Mountain in Acadia National Park.

→ Your ability to internalize and then communicate the subject before you is revealed in how you decide to lay out the overall design, the colors you choose to use to express what you feel as opposed to what you see, and in your clear and direct brush strokes, which are as personal as your own handwriting.

That's why the evaluation process is both an emotional and an intellectual moment when I ask myself whether I have revealed my innermost feelings based on the experience. All those little nuances, such as brush work, glazing, softening and color adjustments, not only help to convey the mood at hand but will also unveil who I am as a creative painter.

When you're wrapping up one of your paintings, don't conceal your personality. Be accountable for who you are. When it comes to expressing your feelings visually, you should let it all out without holding back. Take chances and overextend. When push comes to shove, strong design with drama will never let you down. In fact, in the next chapter, we're going to look at ways to make your paintings more personal, more expressive and more dramatic.

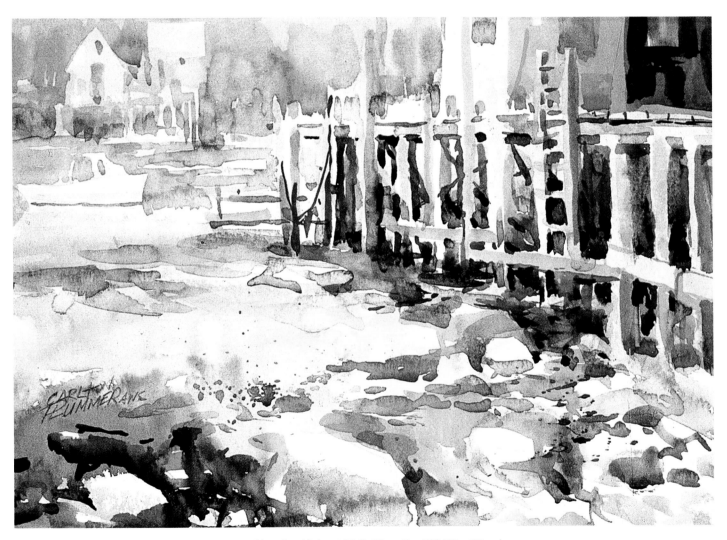

Morning Light at Little River, 7 x 11" (18 x 28cm)
This small painting was executed quickly without drawing and captures the feeling of sunlight without any fanfare. Most of the shapes were left flat without detail. I then added the dark tones between the pilings to make them glitter in the light. By working quickly, I was able to capture a fleeting moment of exciting light.

Now that you're more comfortable with the basics of creating a painting, learn how to intensify the drama of your subjects with lighting, design, value and color.

Making the difference with drama

Emotion and drama go hand-in-hand, and have always been important and essential factors in personal expression. Exaggerating an emotional feeling can take a painting out of the ordinary and into another level of individuality and uniqueness.

Like the director of a play, you have at your fingertips the opportunity to control the mood and tone of any situation and to express it explicitly with drama. Sometimes artists are lucky enough (I call it synchronicity) to encounter a dramatic lighting scenario or composition in its natural state. All you have to do is use your basic techniques to capture the subject's mood as it appears before you.

However, no matter what Mother Nature provides you, it's always your choice to make a few adjustments that will transform an average situation into one that evokes emotion. You hold the keys to paintings that have soul, that possess your personal touches and engage the viewer in the sensations of the subject. These are the things you should consider throughout the painting process if you are to rise above a storytelling or ordinary representation of the scene in front of you.

If you look to the great masters of the past, you will discover how they utilized

drama continually to put forth their personal concepts. Some focused on value control, others emphasized color and still others used some of those pesky rules on design you're always hearing about. Allow me to explain the tools available to you today.

Using light to add drama
Landscapes and seascapes already have one built-in quality that automatically sets a tone — light. So perhaps the most obvious way to establish an emotional feeling is to work or gather references at the time of day and under the type of atmosphere that are creating the kind of moody light you're hoping to achieve in your painting. You can also use your imagination to envision how your subject would look under various light conditions.

Side lighting when the sun is lower in the sky, for example, is quite common, bringing out clear colors and reflecting warm tones onto the sides of the objects. This results in cast shadows that seem to creep across sunlit areas and over the terrain, becoming an integral part of the composition and providing negative and positive shapes. The composition becomes an interesting array of lights and darks with the middle tones creating a cohesive, yet dramatic, composition.

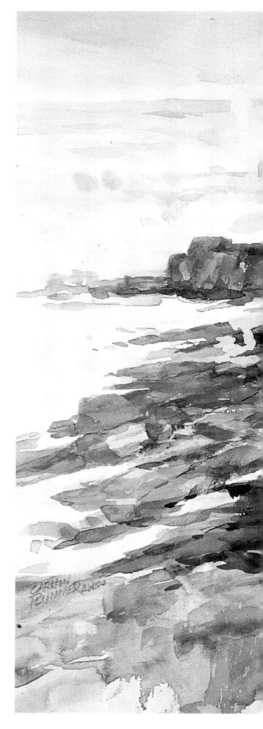

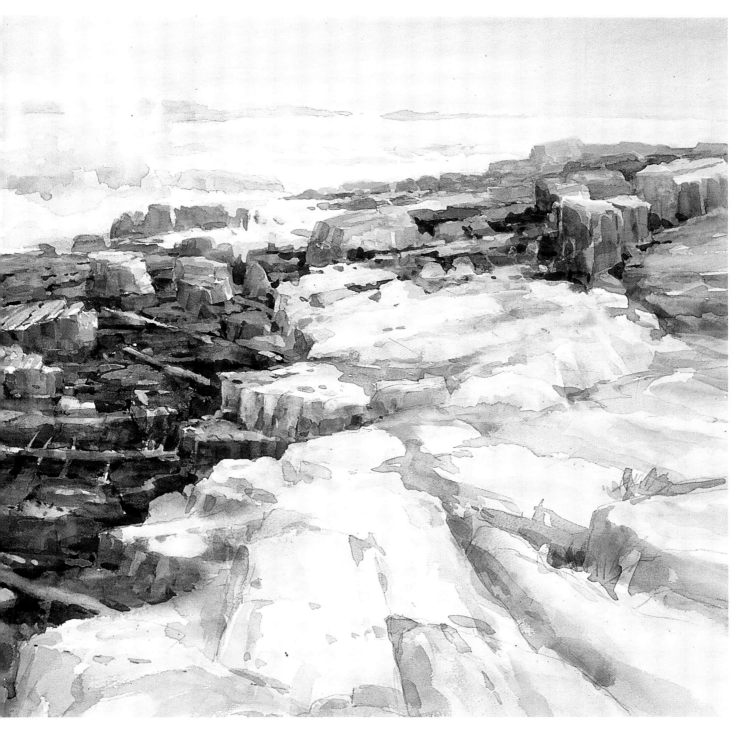

Surf and Snow, 22 x 30" (56 x 76cm)

What a dramatic painting! You can almost hear the ice cracking and the surf pounding. To accomplish this, I used such tools as design structure and value pattern. The diagonal snow area, occupying a major portion of the painting, thrusts boldly like a wedge into the heart of the composition. The darker area of seaweed and wet ledges presents a needed contrast. The sky and distant water become squeezed in an accordion-like manner, accentuating depth. The result of all this exaggeration is energy!

Top lighting

Top lighting usually indicates a light source from above, such as the sun high in the sky. Shadows are short in length on the ground or on the water, or even non-existent, but quite intense on the sides of the objects all around. However, there will be situations where occasional cast shadows will appear from higher shapes. In the case of ledges, for instance, grooves and crevices will appear darker in value, providing contrast. This type of light can often be stark and austere with a surrealistic effect, adding more drama to your painting.

Back lighting

Backlighting is my favorite lighting situation, perhaps because of the mystery and depth that transpires from having a light source from somewhere in the background, creating flat silhouettes that set the mood and bring out drama. Light from the side will also create a backlighting situation if it is well back in the composition. This flatness without detail can add punch to the composition and goes far in dramatizing the mood, sending home your message.

Incorporating reflected light and color

The effect light has on objects is another tool you can use to add excitement to your paintings. Light has a tendency to reflect off bright or reflective surfaces, often carrying the color of that surface onto other, nearby objects. For example, light will reflect off the sea or sky, coloring a white building on the shore with the same tones. On a sunny day with all that luminosity radiating around, color can even be reflected into shaded areas, although it is also present in filtered light. Sometimes I refer to reflected light as "bouncing light" because the light and color seem to bounce from one area to another.

It takes some practice to train your eye to see reflected color, but once you can perceive it, you can begin to use it to bring drama to your paintings. Bouncing light can transform otherwise boring objects or passages into very colorful arrays of illumination or even just subtle nuances that add spice to your paintings. Mother Nature provides us with such wonderment — it is there for your interpretation.

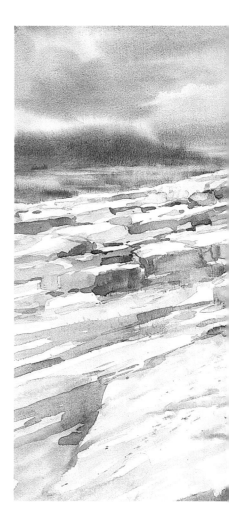

Art in the making A series of silhouettes

As you review this three picture demo, follow the series of silhouettes and see how each set plays against each other, creating depth and interesting new negative shapes. It's fun to use lots of pigment on a very wet surface and let it run and diffuse. I try to go with the flow most of the time, but this time I really let loose!

1 Pushing pigment around

On top of a light wash in the background, I worked very wet to directly apply the first washes. I "pushed" the paint into the water with the brush to create soft edges on my silhouettes. I dropped in more light pigments and did all of my adjusting while the paper was still wet or damp.

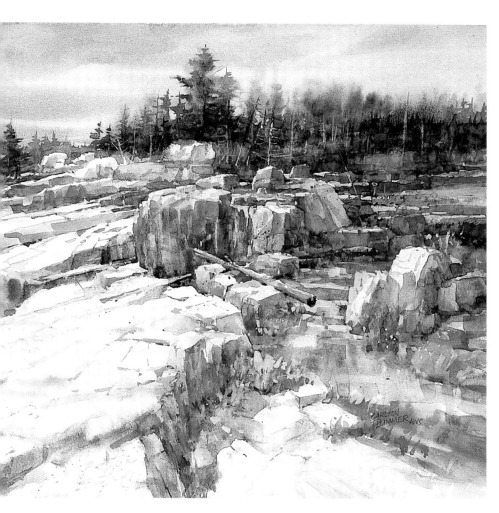

Sunlit Ledges, **22 x 30" (56 x 76cm)**
The massive rock ledges that thrust up and into the composition catch top lighting from the midday sun. Much of the highlighted area of ledge is the white paper with a few light tints of warm colors brushed in, revealing the sun's radiation.

The shadow sides and the crevices accentuate the brightness and reinforce the strong diagonal movement back into the painting. The sky and deeper evergreen treeline also add to the contrast and drama.

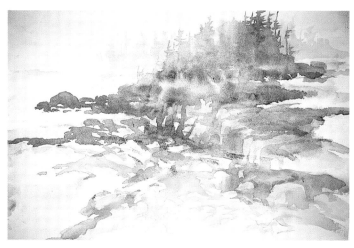

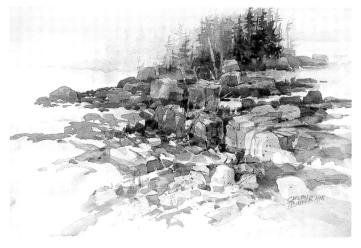

2 Layering silhouettes

Next, I started to work into the first silhouettes, slowly breaking them into smaller silhouettes that represent more information going on within their boundaries. I used lots of pigment because the surface was still wet, staying within analogous color combinations for continuity and harmony. As I laid down these shapes, I paid attention to the negative shapes as well to create an attractive vignette with the design fading away toward the edges of the paper. Some linear brushwork was then introduced.

3 Unifying with dark accents

To complete "Coastal Silhouettes" (16 x 20" or 41 x 51cm), I applied more dark blue-violet tones and, while the surface was still wet, scraped out a few highlights. After the paper had dried, I spattered and drybrushed even more to create some interesting textures, especially in the crevices.

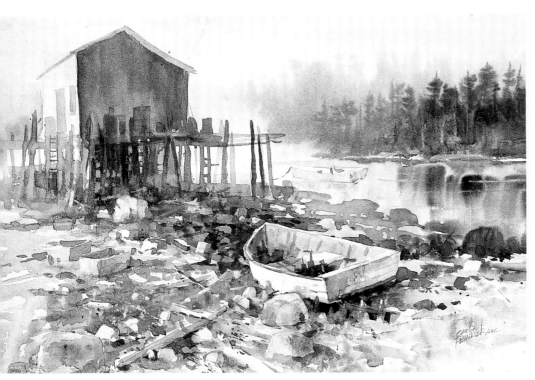

Beached Boat, 22 x 30" (56 x 76cm)
The side lighting on the silhouetted fish house and the beached boat at low tide comes from the early morning sun in a remote and serene inlet on the coast of Maine. The deep shadows on the building and the darkened flow-through area flowing to the beached boat add the needed contrast. The flow-through shape also acts as a connector from boat to wharf area, establishing a cohesive unit. The warm and cool colors work in harmony to evoke a feeling of sunlight.

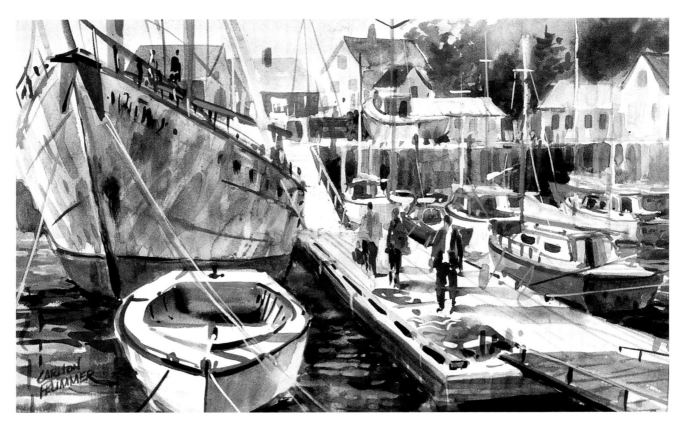

Bouncing Lights, 15 x 22" (38 x 56cm)
Here, real drama is established with luminous, reflected light dancing all over the hull of the large boat. The smaller row boat moored in the foreground with its strong contrast is not the focal point but acts as a lead into the hull of the large boat, catching reflected light from its environment. Actually, the figures form a secondary point of interest. Notice the way the bouncing color supports the triangular composition, rowboat to hull to figures.

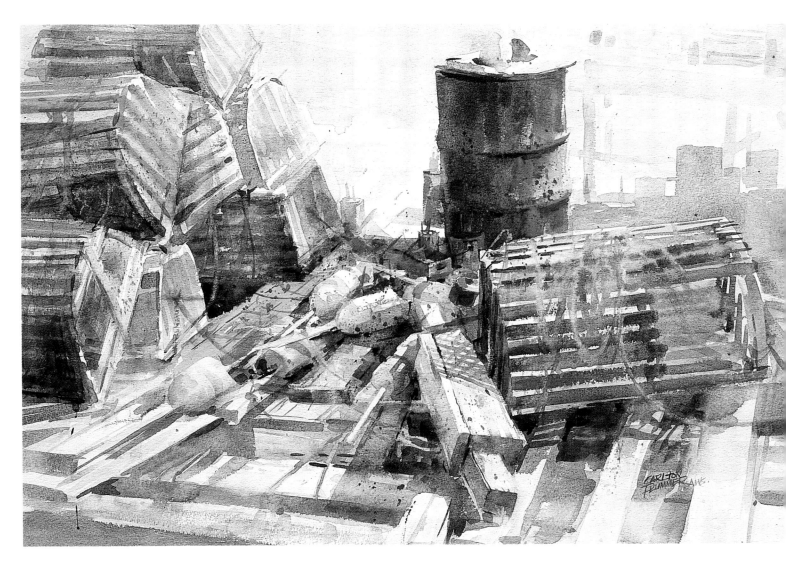

Dramatizing by design

In addition to the qualities already existing in the subject, there are artistic decisions you can make that will further enhance the emotion and feeling in your work. Dramatic movement or rhythm, for example, can be achieved in a composition by laying out a series of shapes, augmented by brush strokes, that form a "design structure". The Old Masters depended on these structures to dramatize their paintings.

When I talk about a structure, I'm referring to the way in which several shapes of similar value or color can be connected. Done deliberately by adjusting colors and values as needed, the shapes become a closely related mass, and that overall mass acts as a cohesive agent, visually tying objects

together. The eye tends to follow this united mass of shapes as it flows rhythmically through the major portion of a painting, which is why my old painting buddy, Ted Minchin, coined the phrase "flow-through shapes" to describe the structure provided by the mass.

Although there are many possible design structures or patterns of "flow-through shapes", I've found the following to be the most conducive to marine painting. The "diagonal" or "zig-zag" structure appears in many of my coastal compositions. The quickly changing pace of this pattern generates a staccato movement that evokes energy and drama while effectively directing the tracking of the viewer's eye through the composition. The journey can be ➔

Lobstermen's Still Life, 22 x 30" (56 x 76cm)
The barrel is the only strong silhouette, which is why we are attracted to it quickly, making it the focal point. It seems strange that with all of the detail on other objects, the simple barrel form is the area of emphasis. That's the power of the silhouette coming from back lighting. Notice how the subtle silhouettes in the background break up the area without distraction.

Art in the making Reflected light and color

On a sunny day such as this, the light bounces off the large objects, reflecting their colors onto nearby objects. By including and accentuating these reflected colors in my painting, I brought unity and harmony to the work.

1 Drawing lightly

I didn't draw too much to begin, just enough to block in the important areas and to ascertain the perspective. Although it was important to indicate the buildings in proportion to each other, as they appear in the picture plane, the foliage and rocks were suggested loosely to indicate areas to paint in a flat, not detailed manner. Later, when I went to paint the rocks and sea, I used a brush to draw initially.

2 Setting a mood ▶

Next, I applied very light washes wet-on-dry to most of the painting, using a pale gray-blue to set the mood. I left the white paper on the sunlit side, highlights and roof tops, some of which I will cover with warm tones in the next step.

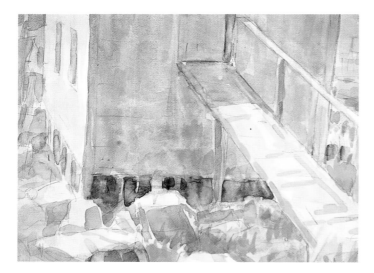

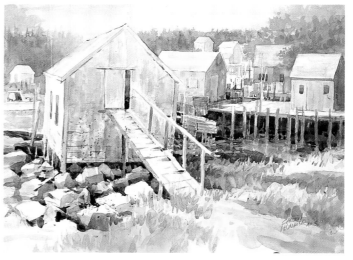

5 Connecting with spatter

This close-up view shows the interaction of the reflected colors. The spatter added texture as well as connecting color. Note that it was important to retain the same value of the established value. If I had gone too dark, I would have lost the feeling of luminosity.

6 Overlaying with mid-tones and accents

At this stage, I put in middle tones, both warm and cool, under the wharf and buildings, including the shadowed sides away from the light and foliage. This started to bring out the basic design of the painting and reinforced the feeling of early morning light. The drama really became apparent when I applied the final dark areas and accents. It was important not to overdo the pigment and darkness. There was some variation and light within deep shadowed areas because I used warm and cool colors wet-into-wet.

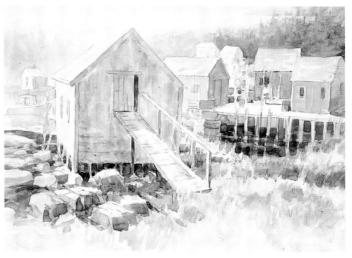

3 Warming up

To portray the warm sunlight, I added warm washes of Aureolin and Raw Sienna to areas such as the grass and roof tops. A little was added lightly to the sky as an overlay to add a hazy light. I applied these washes while the paper was still damp.

4 Reflecting color

Light reflecting off the grass creates a yellow-green on the side of the large fish house, so I put that in wet-into-wet with Quinacridone Gold and mixes of yellowish-greens. The reds and other warm tones of the smaller buildings were then reflected into the water below them. Using these same colors throughout the shadows helped to harmonize the painting while giving more definition to the objects.

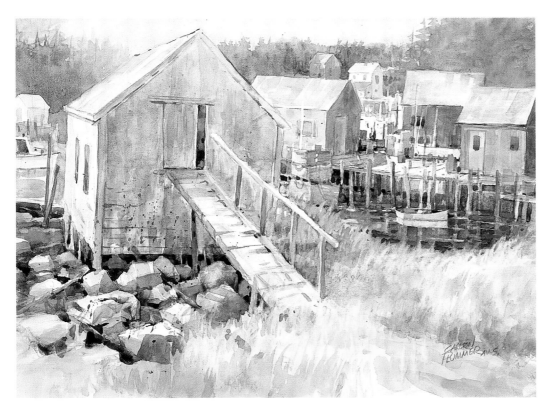

7 Reworking for a better design

What I thought were the final touches to the painting "New Harbor, Maine" (15 x 22" or 38 x 56cm) turned out to be an introduction to another major adjustment in the focal area. I felt the wharf area was too dark and unbroken. By lifting off some pigment to reveal the light of the water showing beyond the wharf and then adding a small rowboat, I broke the composition into better light and dark patterns that balanced the rest of the painting. Although the large building occupies a major portion of the composition, we now look beyond it into a more active area of the wharf. The light patterns of grass in the foreground move you back in the painting.

Art in the making Flow-through shapes

In this demo, you'll see how the greenish tones form a zig-zagging flow-through shape, also creating the negative space, that moves the eye along the low-tide beach to the silhouetted trees in the background. It is the cohesive agent that also clarifies information about the scene.

1 Painting boldly with the brush
Initiating the approach to the composition with a piece of 140lb cold-pressed paper attached to a piece of foam core board, I proceeded to brush in the basic shapes and directional lines with a small round brush charged with a muted cool gray (Ultramarine Blue and Raw Sienna). Realizing that I could wipe out lines easily with water, I painted deliberately, without fear. This kept me loose and spontaneous, allowing me to go in any direction without the feeling of following a controlled drawing. Sometimes I pulled my brush sideways to make tinted shapes that helped me see my design patterns.

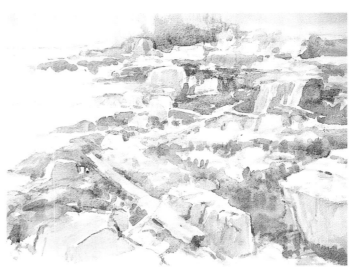

2 Applying the middle light tones
By applying middle light tones, I could see where my design was taking me without a total commitment of applying darker values. I blocked in the entire sky to set the mood with a 3-inch flat brush on a wet surface, using enough pigment to compensate for the extra water. Pulling the wash across and down to the horizon, I overlapped into the water a bit. My choice of color was a deeper blush tone made up of Cobalt and Quinacridone Gold that continued to be applied onto the island, trees and down the low-tide area.

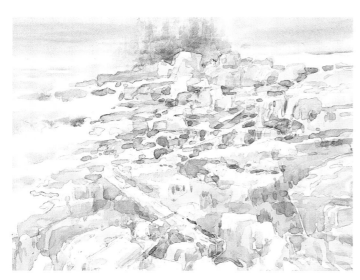

3 Carving out the negative areas
This is the step that would make or break the painting. With a medium-sized round brush loaded with muted green, I proceeded to carve around my rocks, logs and other positive shapes, leaving them in a lighter value. While the greenish tone in the negative area was still wet, I immediately applied warm color — Quinacridone Gold, Raw Sienna and areas of Burnt Sienna — letting them interact and disperse.

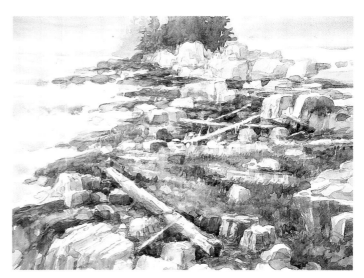

4 Introducing the middle darks
Next, I introduced the middle dark colors to pull the shapes together and to begin to reinforce areas of emphasis. I used Prussian Blue, Burnt Sienna and a mixture of Sap Green and Quinacridone Gold, misting water over the areas to be painted that had become too dry. I then established the silhouette in the tree area, using the dull greens and earth color. At this point, I could see the flow-through shape emerging.

→ exciting, punctuated by areas of emphasis along the way.

Similar to the zig-zag but with a smoother, softer rhythm, the "serpentine curve" also gets the job done. An example of this would be the waterways and landmasses that are similar in color, value or texture that sometimes move gracefully into a composition, forming an S-like shape and movement. It presents a much calmer mood than the zig-zag with its more abrupt changes of direction.

Convergence design

A "convergence" design structure, related to the diagonal or zig-zag, combines series of shapes coming from several directions or angles that lead the eye into pocket-like negative spaces and onto other negative areas. Rocks, logs or other similar shapes within the subject can converge, forming a series of focal points or areas of emphasis. In a seascape, these series of converging shapes often lead us in and out until we reach the

impact area of surf and rock in the background. This interlocking effect forms new shapes, although one should be more important than the others. Here again, directional changes generate a mood of excitement.

Axial design

An "axial" design is dependent on a vertical shape or shapes overlapping a series of shapes linked along a horizontal baseline. Where the two directional emphases come together, they form a focal area that unites the two directions of activity. Mood is dependent upon the subject matter, value key and color control, but there is typically a sense of stability that comes from the interaction of the two opposing active areas.

Flow-through

In discussing design structure, I often refer to the "flow-through area" as well, which is the same concept as the "flow-through shapes" only applied to the negative shapes instead of the

positive. The shapes making up the flow-through area are also connected with similar value or color and may consume a major portion of the painting. This concept of flow-through shapes is so vital because it adds drama and cohesiveness to a composition.

Exaggerating the value pattern

As I just explained, the design structure is built on linking several shapes together, typically through similar values. Thus, understanding the concept of value (the relative lightness or darkness of a shape) and learning to control value are essential in pulling every painting together. Paintings often fail when the artist gets carried away with too many busy shapes coming from too many different values or, conversely, when definition is lost due to overly similar values all running together.

Most often, a painting's design is based on predominantly high-key (light) values with dark accents or predominantly low-key (dark) values

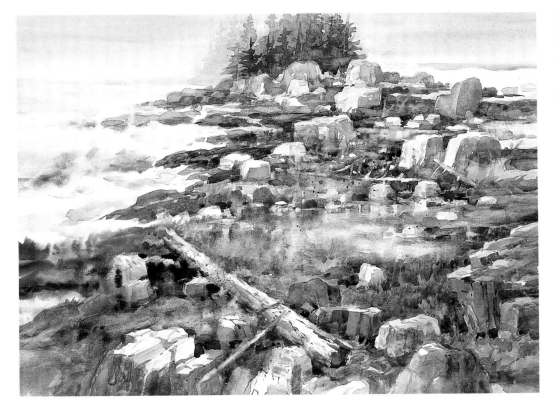

5 Reinforcing with final accents and over-painting

Working quickly, I hit the areas that needed darks, such as under the logs and around the rocks. A few areas needed to be pulled together with a glaze of warm gray. A final spatter to indicate texture of the low tide and a softening of the edges put the finishing touch on the seascape.

However, after living a while with the painting "Mystery Island" (15 x 20" or 38 x 51cm), I decided it needed to be simplified and softened. I sprayed the painting in the areas to be changed with water and proceeded to pull masses together with a large brush. I also lightened and enlarged the tide pool to allow more light through the middle of the composition, which enhanced the deeper-toned flow-through shape. The soft, reflective area added contrast to the hard edges of rocks and driftwood.

How to paint a silhouette

Silhouettes actually require more care than you might imagine. When painting a silhouette, I usually like to limit my palette to one or several related colors. This limited palette makes it easier to control value and retain the mood. Opposite colors (complements) can be added for contrast or visual vibration, but I prefer to make any color changes while the initial wash is wet, which allows for gradual transitions between colors, not hard edges. However, no matter how many new colors are introduced into the "mother color" of the silhouette, they must be the same value, again applied wet-into-wet. This "same value, different color" approach adds a subtle sense of depth without destroying the basic flat characteristic of the silhouette.

I also try to avoid putting in unnecessary detail, although there can be other flattened-out groupings of trees or another layer of silhouetted shapes to give the viewer a little more information and variety. Sometimes I will even add lines with compressed charcoal, which gives me a soft, linear effect that works well with the silhouettes.

with light accents. These contrasting accents add definition and help to dramatize the subject. It is imperative not to scatter the accents around, which creates confusion, but rather to place them judiciously in interesting rhythms that will direct the viewer's eye into and around the focal area and then around the painting.

However, a narrow range of values can also effectively create a subtle mood. Both an all-light-value painting and an all-dark one tend to have an air of mystery, and perhaps it's the elusiveness that is so intriguing.

Specifically, drama can be expressed in light, airy, "high-key" paintings, in which values are kept high on the scale with very little contrast. Think of a misty day at the coast with the fog bank hovering over an island. The entire painting can be accomplished with as few as three values. The color intensity will be low, requiring less pigment than usual. Spraying sections and lifting may be needed to soften edges and obliterate details.

Limited illumination can also create an interesting, sometimes eerie mood. For example, on the Maine coast, lobster sheds where fishermen keep their gear

are dimly lit, usually from a small window or an open doorway. If it is a dull, overcast day, the interior has hardly any contrast at all. A low-light subject like this would result in a "low-key" painting with the majority of the composition taken from the darker end of the value scale. A glazing technique may be useful in bringing down the contrast of values in this situation.

Since the question of how dark or light is always on our minds, it is useful to look at value charts, especially in relation to actual paintings as they reveal the relationships of the values. As they always say, "everything is relative". We live in a world of illusions.

Creating mood with color

Now that you have a better understanding of dramatic value relationships, let's look at the emotive effects of color. The contrast of warm and cool, saturation and all the various color harmonies play a major role in developing very personal ideas and are instrumental in reinforcing that special mood. There are some who will say you can't have a lot of color and be effective with value, but if you have a clear understanding of value control

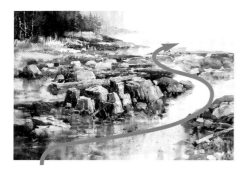

Ebb Tide Inlet, 15 x 22" (38 x 56cm)
We are led leisurely back into this painting to a small silhouette of a clam digger by his boat. The serpentine curve creates a much softer rhythm than the zig-zag, resulting in a mood of solitude. The first wash of dull blue set the mood and served as the mother color for the waterway and the reflections. The rocks of grayed down blues were followed up with warm washes of earth colors. The dark silhouette of the woods serves as contrast, as it goes off the top of the composition.

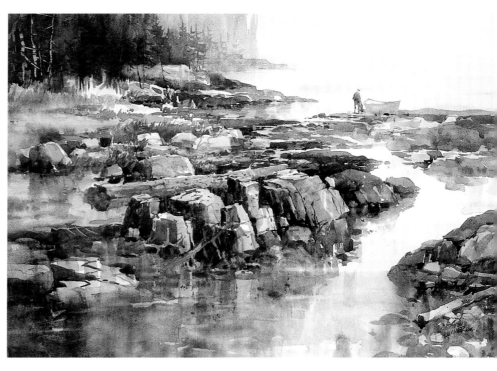

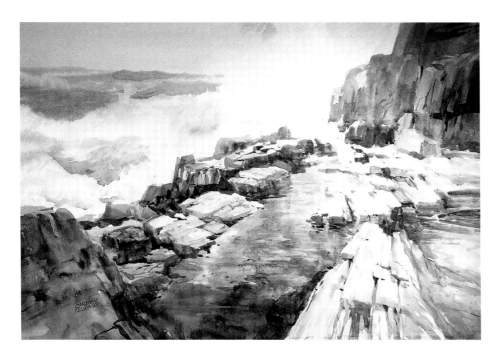

Tidal Surf, 22 x 30" (56 x 76cm)
This painting started out as a demo on location at Pemaquid Point, Maine, but was completed back at the studio. It is interesting to see how the "flow through" shapes, separated into two very dissimilar masses and starting from different areas in the painting, converge diagonally into the impact area where the surf pounds against the ledges. The two light areas act as one to hold the composition together.

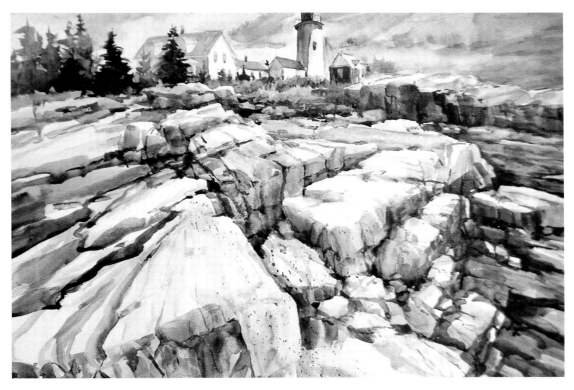

Pemaquid Light, 20 x 30" (51 x 76cm)
With a series of larger shapes making a zig-zag, diagonal, the sunlit ledges move the eye back and up to the lighthouse high in the composition. This started as a workshop demo in the early morning light, working on medium surface illustration board. I worked wet-on-dry without drawing with a pencil, using a light, dull Cobalt Blue and Raw Sienna to block in the basic design, followed with Quinacridone Gold mixed with the dull Cobalt for the mid-tones.

> **"There are some who will say you can't have a lot of color and be effective with value, but if you have a clear understanding of value control and realize that each color fits into the value scale from light to dark, the world of color is at your fingertips.**

Lobster Cove Lights,
15 x 22" (38 x 56cm)
Warm lights appear in a variety of areas and shapes, starting in the immediate foreground with the traps coming off the edge of the paper on a diagonal and leading the eye inward. Actually, the rhythm is based on a staccato, zig-zag movement of light values continuing up onto rocks and onto boats in the background. This bouncing pattern of light accents creates a rhythmic path throughout the composition, evoking a sense of early morning light. The contrast of the cool, blue-green water and the juicy wet green backdrop puts the final touch on a sunny morning on the coast of Maine.

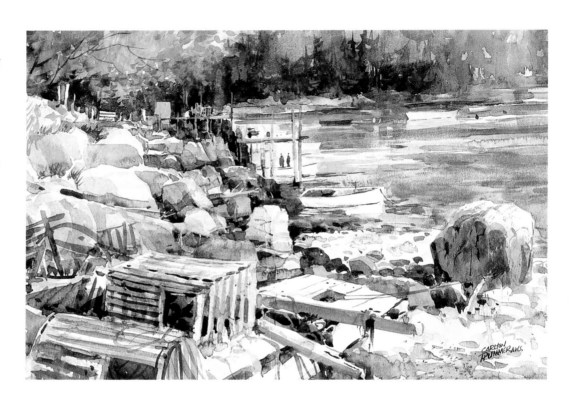

Tidal Rocks, 8 x 11" (20 x 28cm)

Initially, this composition worked well with a series of silhouettes behind the tidal boulder, which occupies a very large area. The drama is enhanced by the vigorous grouping of smaller rocks, converging at the boulder from several directions.

But then I asked myself, What if I added a strong vertical selection of trees on the right next to the boulder? This resulted in a very effective axial design structure and reinforced the vertical-horizontal movement I had established originally. The addition of rocks on the horizontal base emphasized the axial design and added to the overall drama.

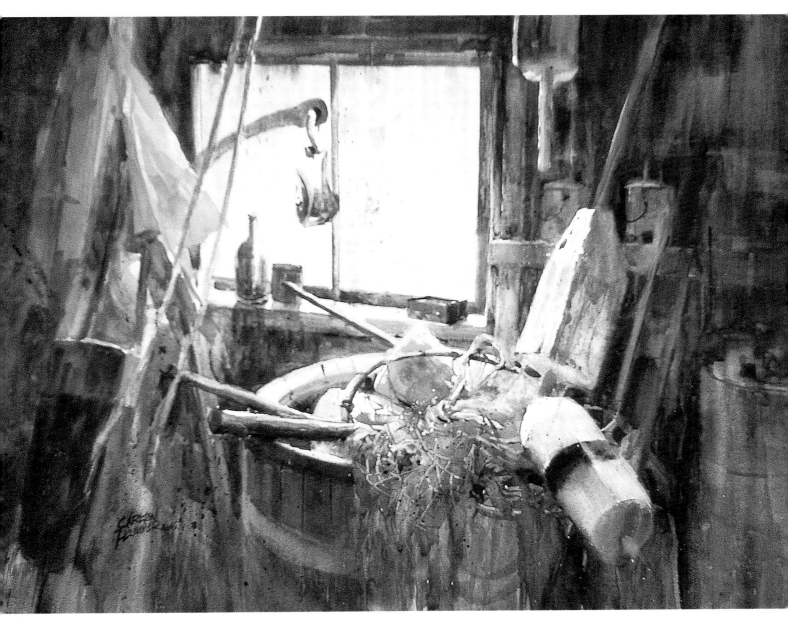

and realize that each color fits into the value scale from light to dark, the world of color is at your fingertips, offering endless visual possibilities. Color used to enhance mood may seem complicated, so let me break it down into some basic approaches that will ease the pain.

Perhaps you have noticed by now that by limiting color, an artist is better able to convey ideas. In general, you will find that carefully selecting your colors and limiting your palette are not only extremely effective in developing mood and emphasizing drama, but make color mixing much easier, especially for anyone working with a new

environment or subject matter. Limiting your color palette practically guarantees pleasing, harmonious color.

The best way to begin is to choose a single color to dominate, or appear most often, in your composition. Naturally, you should choose the color — sometimes referred to as the "mother color" — that best expresses the mood you're after. By repeating this color throughout a painting, the viewer will be able to visually track it around the composition, thus enhancing their entertainment and interest.

When choosing the rest of your palette to go with the dominant

Lobsterman's Interior, 22 x 30" (56 x 76cm)
How often can one find a ready made still-life? This a predominantly low-key painting, although some very light values are coming from a focused light source. Values became interwoven in the semi-darkness, but objects picked up light and shadows out closer to the light source. It was fun to throw in middle-toned washes of color, knowing that I would be adding darker tones, so worrying about lighter tones was not a problem. If it got too dark, I could lift paint out before it dried. Textures and accents were added last.

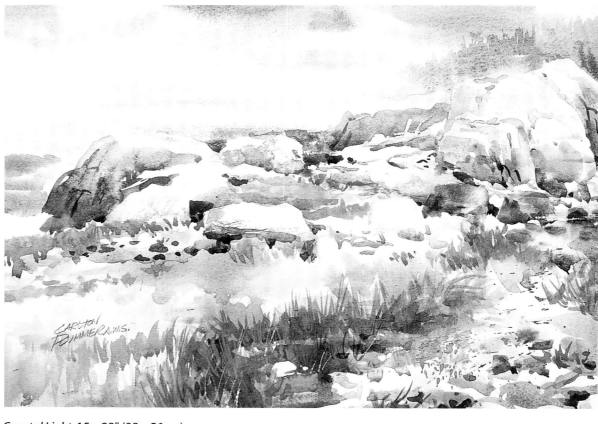

Coastal Light, 15 x 22" (38 x 56cm)

This was a demo for my workshop students to show reflected light, even on an overcast day. It also provides a great example of a very limited and muted palette in high-key values — the soft, overcast day has been captured without much fuss. The white of the paper serves as the highlighted area of the ledges.

color, you may want to look to the neighboring colors on the color wheel — for example, blue, blue-violet and violet — which are called "analogous colors". You can get a similarly harmonious effect by employing something I call "saturation", where every color used in the painting has been mixed with or glazed with the color that you want to permeate the composition. Then again, you may want to limit yourself to many values and temperatures of the same dominant color, referred to as a "monochromatic" painting, although this approach is a real test of value control. In any case, using a few colors that have much in common with each other reinforces the mood.

When you're ready for a greater challenge, you may want to try pairing your dominant color with a little of its "complement", the color that sits opposite to it on the color wheel. And for an even more stimulating effect, use the two colors on either side of the complement, known as the "split complements". (To give you an example, red's complement is green, therefore red's split complements are blue-green and yellow-green.) The contrast of color complements is very effective in creating excitement for the eye. It is equally fascinating to see how the "push/pull" works in a painting when warms and cools are played against each other.

Of course, these guidelines are only a point of departure. Experiment and trust your intuition to create that special feeling. When it comes to coastal and marine subjects, Mother Nature — sometimes with a little help from us humans — provides us with inspiring, captivating subjects. But rather than paint them exactly as they appear to our eyes, we can enhance the drama, interest and personal expression in these scenes by using the artistic tools available to us. Various combinations of lighting, design structures, value patterns and color palettes will yield countless, individualized works of art.

Admittedly, it takes plenty of practice to learn to consider all of these factors in a short amount of time while working outdoors. That's why I continue to recommend doing many small, quick paintings without detail when on location. When you are back in the studio, you can refer to photos and your quick studies to help you execute a large format, carefully designed painting. Even then, simplicity and directness will be important.

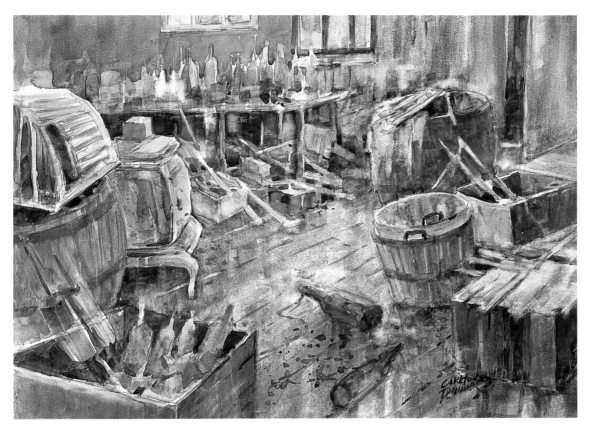
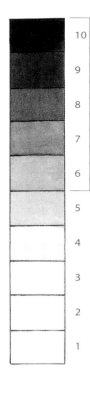

Lobstermen's Workshop II, **22 x 30" (56 x 76cm)**
I found a lobster shed that had great objects to paint but was too evenly lighted. I thought it would be fun to darken the interior so the shapes flowed into each other with lost edges, creating a sense of mystery. The overlapping blues and earth colors subdued the reds and yellows, resulting in a low-key interior with a more intimidating atmosphere.

A word on mud

Referred to in painting, "mud" means a mixture of colors that translate as being dirty, dingy and nondescript. Usually this happens when the wrong pigments have been mixed together or when too many layers of those pigments have been applied.

How do you know which mixtures make mud? Generally, any two secondary colors, such as violet and green, will spell trouble when mixed together. This is because you're actually mixing all three primaries at once. Two complements, such as orange and blue, when mixed in fairly equal proportions can also gray each other to a point of nondescript color or "mud". Similarly, colors that contain black, such as

Indigo, Payne's Gray or Burnt Umber, do very little to add luminosity to a color, so beware!

There is a fine line between mud and very subtle, grayed-down color. Some

artists, including myself, enjoy walking the tightrope, even though it can be easy to fall off. Just remember, the brighter the colors surrounding the subtle color, the better the chances of it translating as mud.

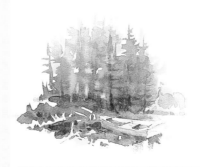
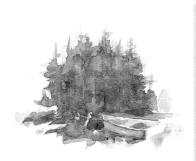

Analogous colors are any three colors lying next to each other on the color wheel. Thus, they have the same color in common with each other, resulting in a feeling of continuity and establishing a specific mood.

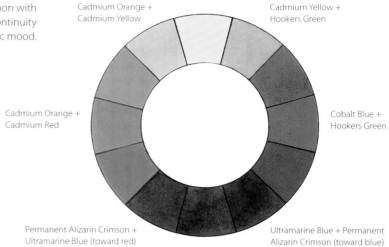

Cadmium Orange + Cadmium Yellow

Cadmium Yellow + Hookers Green

Cadmium Orange + Cadmium Red

Cobalt Blue + Hookers Green

Permanent Alizarin Crimson + Ultramarine Blue (toward red)

Ultramarine Blue + Permanent Alizarin Crimson (toward blue)

***Sunlit Boat*, 22 x 30" (56 x 76cm)**
This painting conveys the mood of sunlight and shade because of concentrated uses of warm tones of **yellow**, **yellow-orange** and **orange**, contrasted by cool washes of **blue-violets** in the shaded area. Except for a few areas in the water and on the beach, I worked wet-on-dry with some glazing to tone down the temperature of the colors. Filtered light adds drama to this quiet scene.

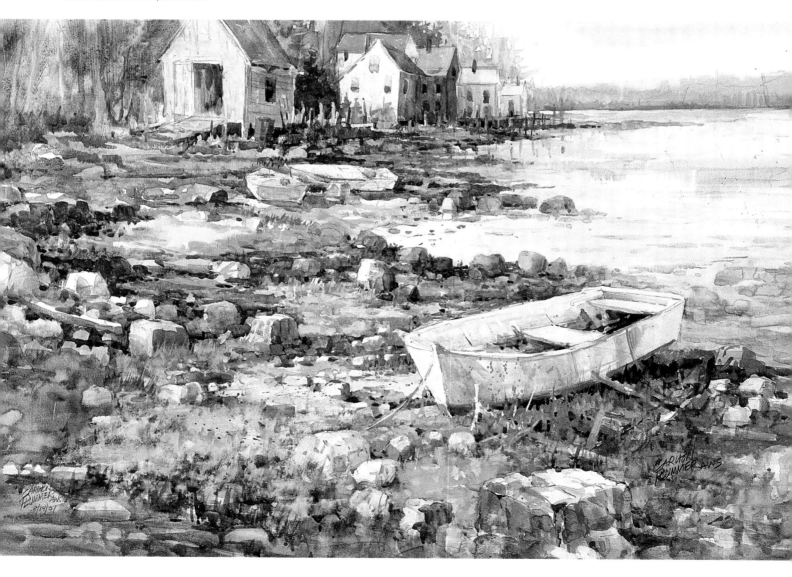

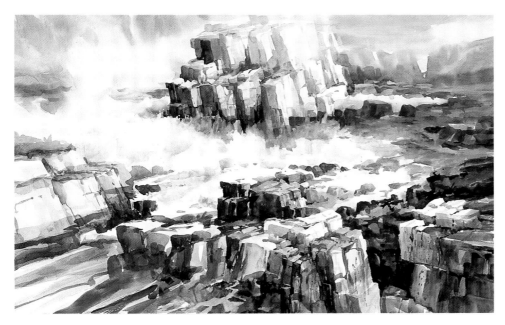

Ledge Glow, 20 x 30" (51 x 76cm)
Repeating a similar color or colors in a painting directs the viewer to various sections of a composition. The repeated color works like a rhythm or beat that moves our eyes around the painting. Here, blue and blue-violet tones echo through the composition, setting up easy tracking. These cool colors share a bit of the limelight with a hint of warm tones that modify and complement them.

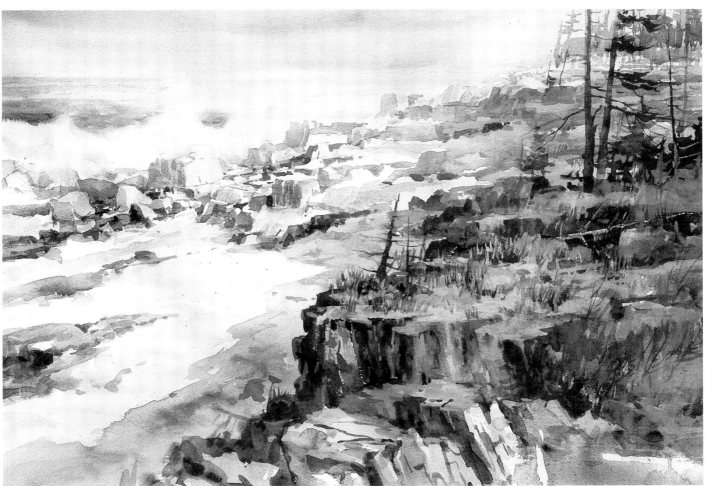

Ocean Island Winter, 22 x 30" (56 x 76cm)
The overall saturation of blue permeates this late afternoon scene in January. Every color has been influenced by glazing over the entire painting with blues. Blue has also been mixed with the other colors. This is an effective way to reinforce a specific mood and add drama at the same time. Several studies were done on location with the final painting completed in the studio.

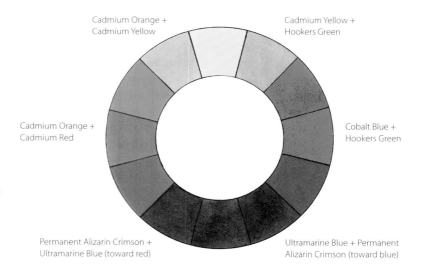

Cadmium Orange +
Cadmium Yellow

Cadmium Yellow +
Hookers Green

Cadmium Orange +
Cadmium Red

Cobalt Blue +
Hookers Green

Surf Light, 15 x 22" (38 x 56cm)

The exciting contrasts of this convergence design pattern is accentuated by the dramatic interplay of color complements. Notice how the **blue** is balanced against its complement, **orange**, as well as its split complements, **yellow-orange** and **red-orange**. Opposite colors can really give a composition punch.

Permanent Alizarin Crimson +
Ultramarine Blue (toward red)

Ultramarine Blue + Permanent
Alizarin Crimson (toward blue)

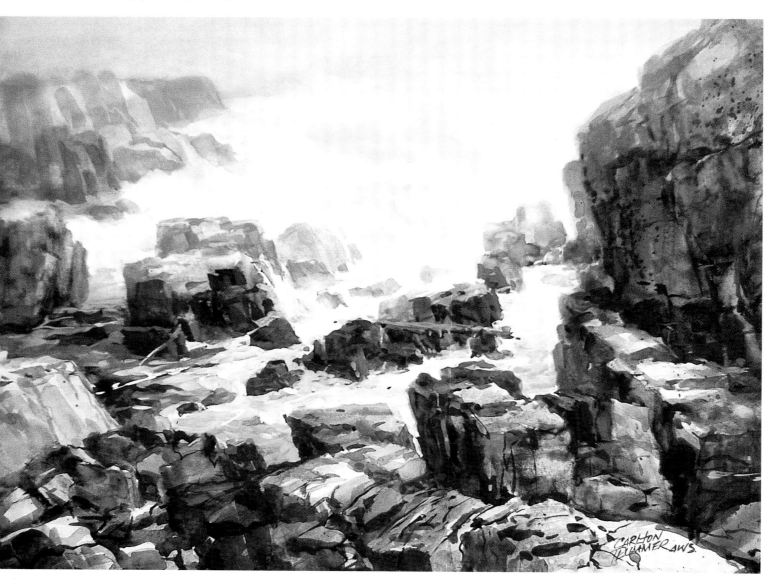

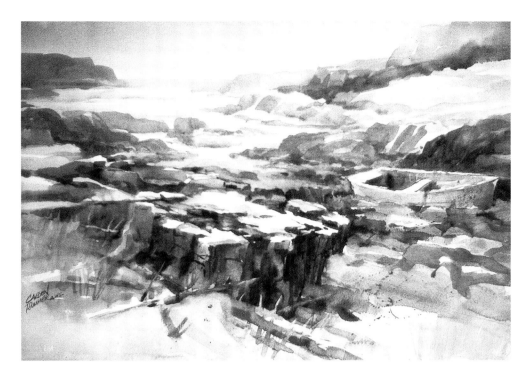

Winter Glow, 22 x 30" (56 x 76cm)
This painting, although somber in mood, gives off an afterglow from the disappearing light on the horizon. This is a monochromatic painting (many variations of the same color) that uses nearly the full scale of light to dark values of blue. Although the light catches the high points of snow-clad ledges throughout the composition, the foreground ledge becomes an eye catcher with the stronger contrast. Notice that I put the boat near it to create a secondary point of interest. Actually, the whole foreground area is strong and that contrast gives depth to the background. The few touches of warmer blue are a welcomed addition to the dominant cool.

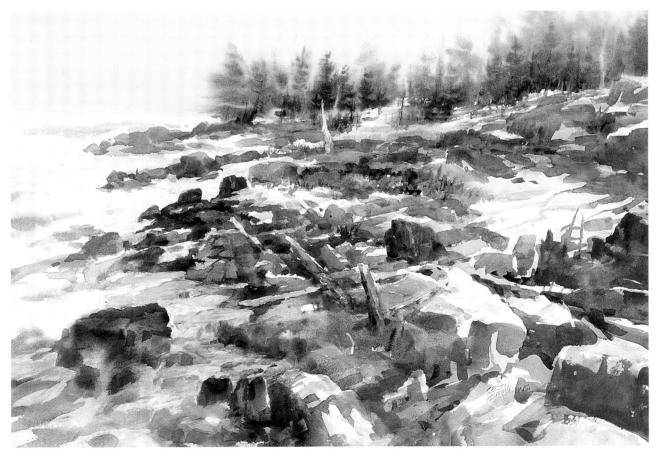

Winter Twilight, 22 x 30" (56 x 76cm)
Notice how the warm notes of color give life to this cool painting. I soaked the sky area and applied the warm wash with quite a lot of pigment to compensate for the wetness. The tree line was painted next so as to have blurred edges. I then applied the light, cool blue tones everywhere I wanted reflected light. Darker tones were applied wet-on-dry.

No matter the place, coastal and marine subjects typically involve the same elements again and again. Here are my best tips for painting these exciting subjects.

Breaking down the coastal elements

My wife Joan and I have traveled extensively around the world to paint. Marine subjects and seascapes have been my main focus since the 1960s, and with our home by the sea, it seems only natural that I would be inspired to express this nautical environment. From this first-hand experience, I've noticed that coastal subjects vary from area to area and from country to country, providing an endless diversity in the basic elements involved. But I've also discovered many useful similarities. Years of close observation have taught me a few things about painting the typical subjects found in most marine situations.

Sky
Quite often, the sky is the determining element in the painting. The lighting conditions and the weather, both indicated in the sky, influence the colors and tonal values that create the mood and emotion in a painting. Even when the sky is not the dominant element in the painting, perhaps taking up only a small portion of the overall image, it still has a huge impact on the rest of the scene.

For the most part, skies are best painted with a wet-into-wet technique in order to get the soft transitions of color and value needed to suggest space stretching back to the horizon. Working wet-into-wet is also effective for creating soft-edged clouds, although occasionally a wet-on-dry approach is useful for showing overlapping clouds.

I recommend practicing doing skies on small pieces of watercolor paper to learn how much water to use and how to make edges that suggest various types of clouds. With experience, you'll be able to lay down any sky in one pass. This is important — keeping your brush strokes clean and eliminating the need for touch-ups by lifting or glazing will help you maintain an essential freshness in this area.

Surf
The endless competition between pounding surf and the coastline straining to maintain its foothold goes on and on, creating dramatic scenarios in design. It is this drama that initially inspired me to paint marine subjects. However, after spending hours watching the rhythmic motion of the water, I realized I could only paint the memory of the action. It's hard to stop the water's movement in your mind so I strongly recommend learning to sit and look at the surf a lot, studying the patterns the water makes at different intervals.

Once you feel the rhythm and patterns and have them set in your

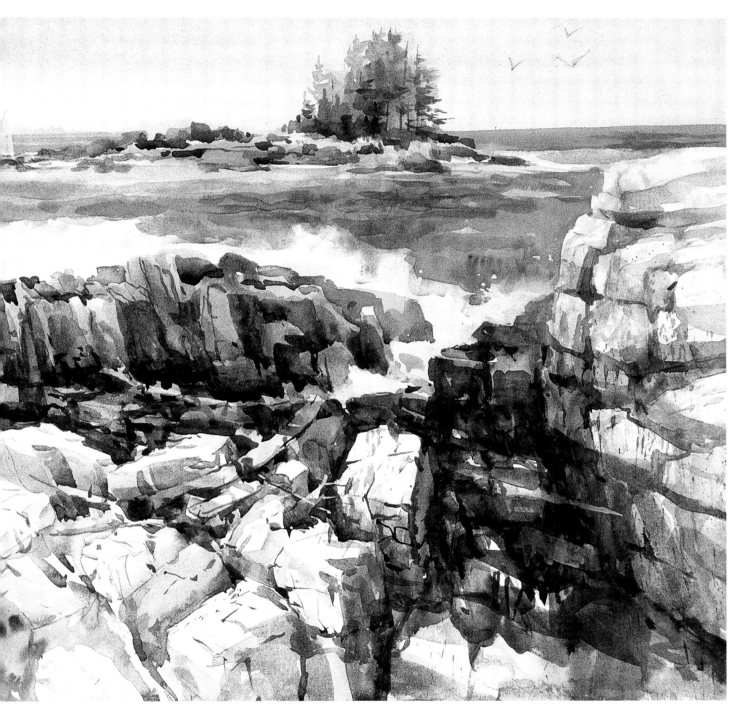

Green Island, **15 x 22" (38 x 56cm)**
This is another demo that caught the essence of a crystal clear day in June on the coast of Boothbay, Maine. Green Island is silhouetted in all her glory against a heat haze in the background, while the surf pounds the craggy ledges. The rocks come in off the edge of paper and into the foreground to lead your eye inward. Sunshine on the rocks is represented with high-key, warm tones and the white of the paper.

mind, you'll be ready to paint. In the initial light washes, I think it's best to focus on value so you can lay out the overall pattern of contrasting lights and darks while preserving the white paper for foam and other light areas as long as possible. If you gradually build up the water from light to dark, you probably won't have to correct errors by lifting or rubbing out later on. Also, whether you're painting wet-into-wet or wet-on-dry, remember to keep the water portion of your painting loose in the earliest stages. You can always go back in to tighten up some edges, making rocks or shoreline from water, but it's much harder to do the reverse.

Calm water
In contrast to the active surf, the calm sea, rivers, lakes and ponds offer serenity and sometimes vastness. Even without wave action, there are generally some interesting, rhythmic patterns on the water created from subtle breezes or the gentle flow of the water. These serpentine patterns that shift and narrow as they recede can be used to show distance and to direct the eye around the composition.

Reflections
Still bodies of water, even water left in pools when the tide recedes, usually possess some sort of reflections. Water acts as a mirror, reflecting a nearly identical image when the water is perfectly calm or a broken reflection when the water is disturbed by some movement. Like the colors of the sky, the colors reflected in water help to set the mood and lighting of the painting.

Reflections are best done wet-into-wet so that they have blurred or zig-zag edges. When you charge your brush with wet pigment, keep in mind that reflections are usually a little darker than the objects they're reflecting, especially when they're positioned closer to the viewer in the foreground. After laying in the wet color, try pulling a brush loaded with clean water in horizontal strokes across the reflections, lifting some of the wet pigment to make subtle breaks in the water's surface.

Remember, a reflection could have shadows cast across it on an angle, but the reflection will always be directly under what is being reflected.

Rocks, ledges and beaches
At some point in nearly every painting, there is a place where the water meets the land, be it huge cliffs or ledges, smaller rocks or a sandy beach. These elements provide wonderful opportunities to incorporate a variety of colors and moods, so there will be times when the

Island Surf, 15 x 22" (38 x 56cm)
A convergence of ledges and surf on diagonals form a focal area in the middle foreground. The rocks and water are more suggested forms, rather than representational. Again, I have played warm against cool while keeping the intensity down in order to evoke the sense of a misty atmosphere, especially in the sky and distant ocean.

Art in the making Rocks and surf
Nothing says "pounding surf" like pure whites, so these need to be planned for and preserved as you go through the painting process

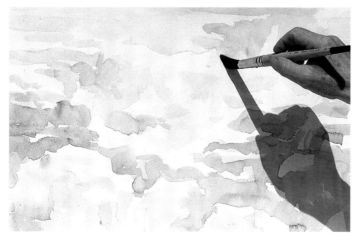

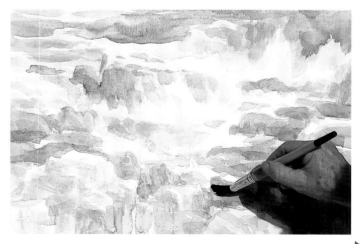

1 Saving the whites
When laying in the initial shapes in a seascape with pounding surf, I've found it best to paint lightly and save lots of white paper. I drew with my largest round brush, using a light dull blue and then some warmer tones in the sunlit areas. In a matter of moments, the broad strokes became shapes and I was right into the painting. Working wet-into-wet and drawing with the brush allowed the colors to mix and diffuse beautifully, and gave me the freedom to change my mind.

2 Sticking with soft, fluid edges
While my initial washes were still damp, I layered on some more warm Quinacridone Gold and Yellow Orange. I then went back to putting in mid-value blues, working around the white foam and painting negatively to define the shapes of the rock ledges. By this time, my painting was getting fairly dry, so I had to go back to soften some edges to keep my water looking soft and fluid.

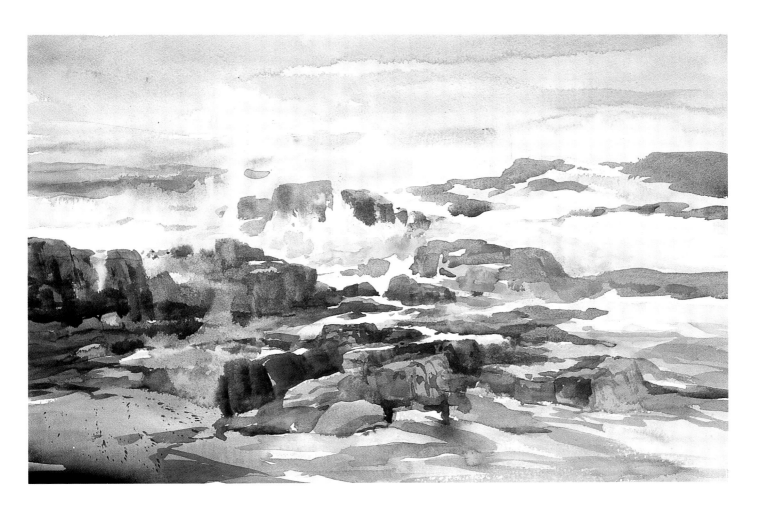

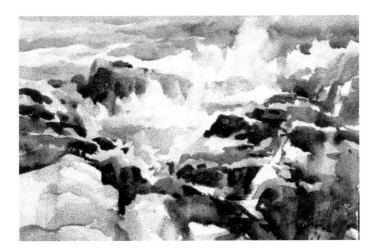

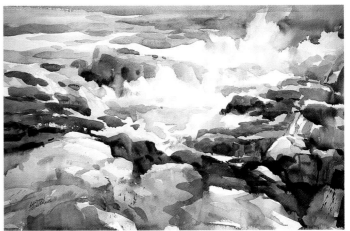

3 Lighting with dark accents

At this stage, I moved into some darker mid-values of blues and blue-violets, using them to darken the distant water which served to accentuate the white of the foam. I then used these same colors to re-state and define the middle-ground rocks so that the repeated tones would tie the painting together and lead your eye around the image. When painting rocks, it's essential to pay attention to the planes that are in sunlight and planes that are in shadow in order to achieve the effect of rock formations.

4 Accentuating rock and surf

The contrasting value of a few final dark accents — both warm and cool — really brought out the dramatic, rocky forms in "Surf at Pemaquid Point" (15 x 22" or 38 x 56cm). But notice that these accents lie toward the center of the painting so as not to draw your attention to the outer corners.

land masses will be the most important feature in your painting.

However, I always paint the water first, making this area larger than I think it needs to be. I then usually carve the land mass or rocks out of the water by glazing over with crisp-edged shapes. I generally start with mid-value and lighter tones, using colors that reflect the mood of the day. I then gradually build up the shaded sides of the rocks and land features, using darker colors in the opposite temperatures. Sometimes I need as many as four different tonal values to give the rocks dimension and depth, although in fog or low light, two values will usually do the trick. Lastly, I apply accents to suggest crevices without too much fanfare.

Vegetation

Nearly all coastal environments around the world have water, boats, buildings and fishermen but the coastal vegetation is usually the one factor that distinguishes one area from another. In Maine, the evergreens, bayberries, blueberries, wild raspberries and wild roses grow among the craggy rocks. In New Zealand, the coast varies from 12,000-foot mountains topped with glaciers to tropical growth along wild sandy beaches. Greece presents a more arid situation with crumbling stone and an occasional sandy beach.

Despite the distinctive features of various types of vegetation, I don't see any need to carefully describe these elements with too much fussy detail. Instead, I suggest them by focusing on the larger shape of the tree mass, foliage or ground cover, describing →

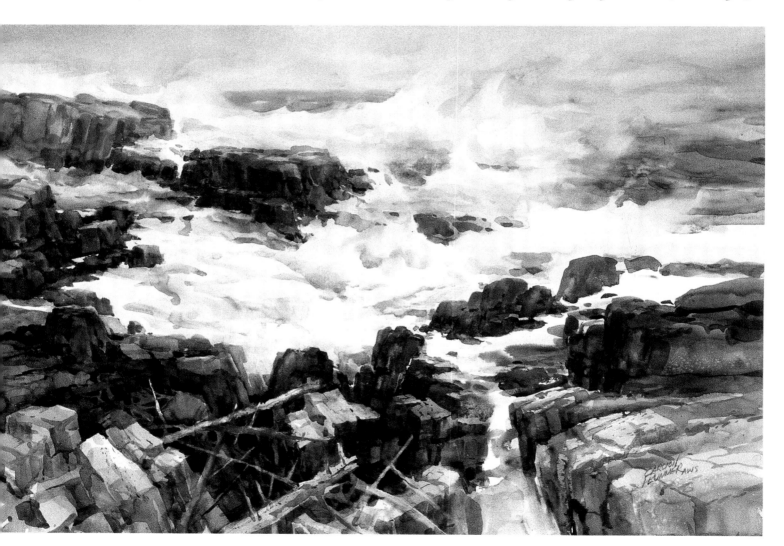

Ocean Fury, 22 x 30" (56 x 76cm)

This surf painting was executed on the ledges at sea level as a demo for my students. The water was extremely rough that day and because I was close to it, I got wet from the spray. I painted directly without any drawing, trying to focus on the action of the water in all its phases. It was important to make quick decisions with the tide rising and the violent movement of the water. I tried to create a light pattern of foam area that would intermingle with the deeper toned water and the wet rocks. I used a No. 40 pointed brush so that I'd stay loose and simplify the large shapes of water and rocks. Much of the water was painted wet-into-wet to keep the edges soft.

Art in the making A beached boat

Ordinarily, I like to be very loose and spontaneous in my paint application so that my paintings can come to life. However, the one time I think it's important to be precise is in my drawing (by which I mean defining the shape with brush and paint) of a boat. A boat's shape has to be accurate or it will ruin the entire effect of the painting.

1 Mapping out shapes
In my cartoon drawing of a rocky beach, I divided the image into more than 15 shapes. To strengthen the overall pattern of shapes, I simplified parts of the ledges and some groups of rocks into larger masses. I then added the shape of the beached boat to provide a note of interest.

2 Drawing with a brush
Guided by my cartoon but not locked into it, I began to draw my composition on my paper. I used a large brush and plenty of cool blue-gray and warm brown pigments on a wet surface so the colors would run and intermingle softly. I varied the pressure on the brush so as to create variety in the line widths. The one place I was very precise and careful was in the drawing of the boat.

3 Connecting through color
To connect the entire painting with color, I added a light wash of gray-blue, carrying it over the foreground rocks, the boat, the middle ground beach, the silhouetted trees and then the shadowed side of the ledge. But notice that I subtly varied the value of this color. This helped to suggest receding space, adding a sense of depth.

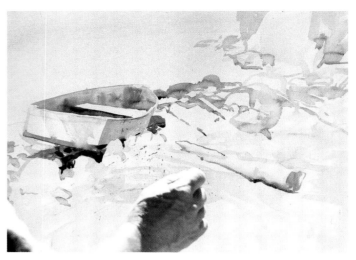

4 Defining the boat's interior
Thanks to a wet-into-wet application inside the boat, I was able to create beautiful color mixes in this small, shadowed area. Again, precision in my painting of this shape was important.

5 Painting around the boat's exterior
By using some negative painting with a fairly dark mid-value, I was able to cast a shadow under the boat to define its exact edge lifted off the beach and, at the same time, define some of the foreground rocks. I stopped at this point to do a bit of spattering to put some texture in this area. ▶

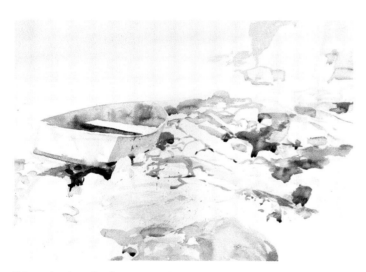

7 Developing the foreground
Next, I turned my attention to the foreground rocks, which act as a lead-in to the central focal area. I continued using warm and cool neutral combinations of my same two colors, Raw Sienna and Ultramarine Blue. The variations of the colors suggest the changing, shifting planes of the rock's surfaces.

8 Improving on the design
A glaze of warm Raw Sienna throughout the beach area helped to unify the debris and small stones into a more cohesive design. I then noticed a powerful diagonal "line" of mid-dark accents leading my eye into the background, a secondary focal area, so I extended it by putting in some dark foliage up along the top of the ledge. This strong angle needed to be contrasted with a few diagonals in the opposite direction, so I used negative painting to subtly carve out some driftwood and fallen tree limbs.

9 Balancing the overall effect
Once I had established a solid design structure in "Boat at Ocean Point" (22 x 30" or 56 x 76cm), I simply needed to add some balancing shapes and finishing touches. Working wet-on-dry, I put in the tree-covered island in the distance to continue the opposing diagonals. I then used a few more glazes and some spattering to suggest the textures and variations in the rocky beach while unifying the image.

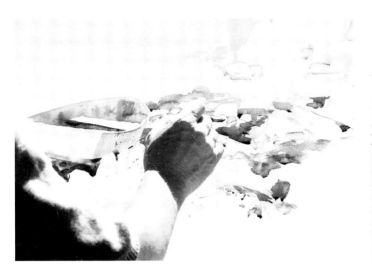

6 Enhancing the focal point
I continued to concentrate on applying mid-values and mid-darks to develop the area around the boat in order to emphasize this major focal area.

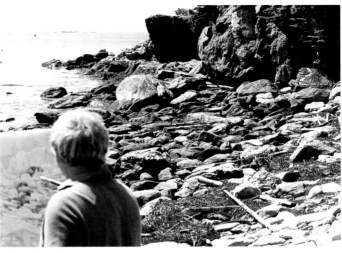

Doing a reality check
Compare this photograph of the actual subject to the final painting below to see just how much I used my own imaginative interpretation to dramatize a rather dull, ordinary rocky beach.

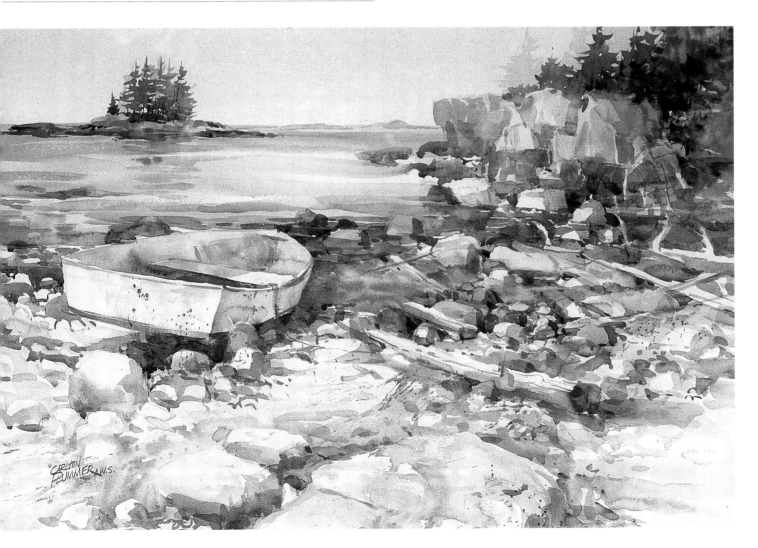

Art in the making Lobster shack

Unlike boats, I do not feel the need to be so exacting and precise when painting any type of building, such as a lobster shack. Although it's important to generally follow the rules of good drawing and perspective, I believe a viewer can see some slight variations and still read the shape as a building. Plus, being just a little "off" reminds us that this is a handmade interpretation by an artist, not a photograph.

1 Making a light guideline
Because this was to be a fairly simple subject with a minimum of shapes, I skipped the cartoon stage. However, because I wanted to be somewhat accurate in my drawing of the building, I drew my image directly onto my watercolor paper. I drew very lightly in pencil and included only the bare essentials.

4 Using complements for effect
Next, I went in with darker mid-values of a reddish-orange color in the shadow cast by the building, which I carried up into the side of the building as reflected color. The noticeable difference in the value of this glaze helped to clearly define the building's three-dimensional shape. I then went in with plenty of greens around the building to create a push-pull, visually vibrating effect against the complementary red, which added excitement to the composition. Some drybrushed strokes suggested the texture of wood.

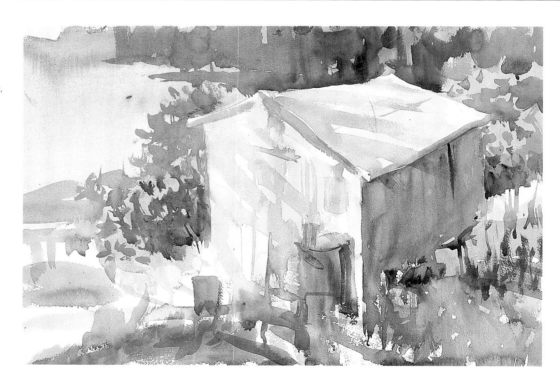

5 Enhancing light and shade
In the final stage, I deepened the areas surrounding the building to emphasize the dramatic pattern of sunlight and shade. (By the way, if you want to study the masterful use of sunlight and shade, take a look at the watercolors of John Singer Sargent, whom I greatly admire.)

2 Creating a sunny mood
Wanting to capture a sunny mood, I started with yellows sometimes mixed with a little orange, applying them all over the composition as a warm base. I left white paper wherever I didn't want yellow in my mix of colors to come.

3 Defining with shadows
Warm light casts a cool shadow, so I used cooler blues and blue-violets to put in the shadowed areas. Notice that I used a wet-on-dry application so that crisp edges would clearly delineate my little lobster shack. Wherever the two light glazes overlapped, interesting neutral and greenish tones appeared.

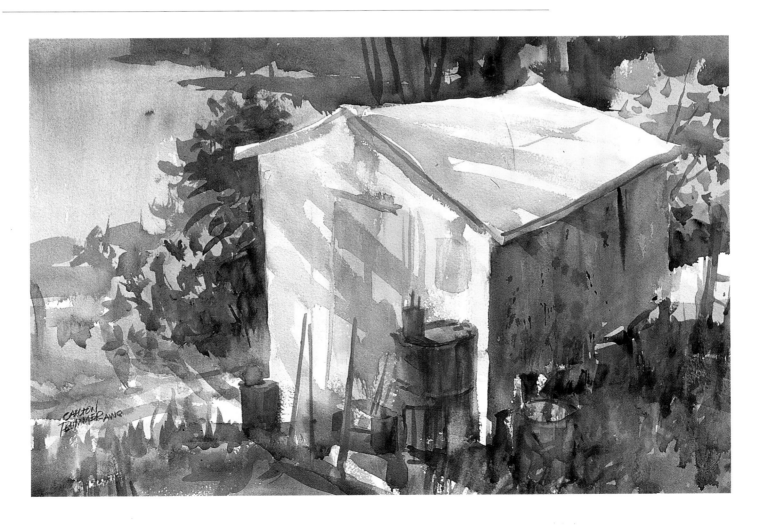

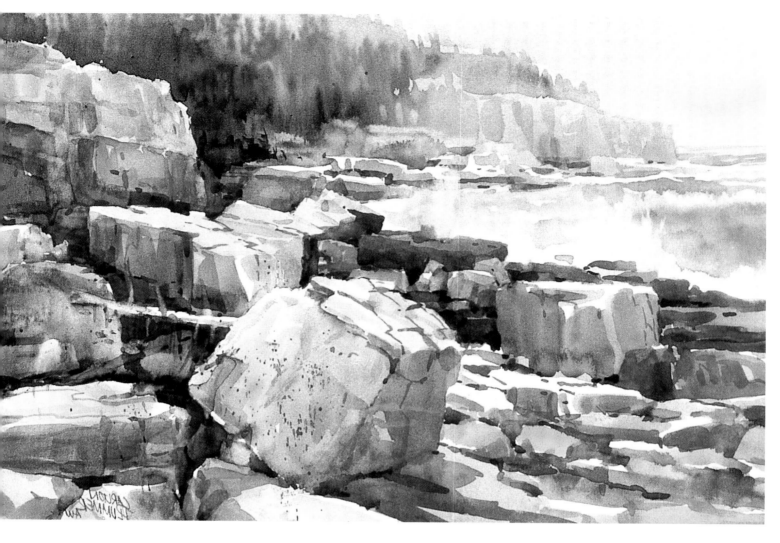

***Acadia Ledges**, 15 x 22" (38 x 56cm)*
Sometimes the local color of your subject
provides all the inspiration and mood you need.
These ledges at Acadia National Park in Maine
have a peach or pinkish hue. When the sun's rays
hit these rocks early or late in the day, they come
alive with a wide range of warm tones, running
the full gamut from yellows and orange-reds to
beautiful cool hues of blue and violet that
accentuate their luminosity. I applied these
colors wet-into-wet, allowing the pigments
to diffuse. The greens of the background trees
set up a triad of color, making a nice contrast to
the yellows and purples.

→ its overall color and including just
enough texture and detail to let you
know what type of vegetation it is.
I want to communicate this information
very simply and directly, leaving much
to the imagination so that the viewer
can become engaged in the mystery
of the subject.

This is why I typically use silhouettes
(flattened, simplified masses) to describe
the general shape of the vegetation.
Additional layers of silhouettes in darker
tones give dimension and provide the
rest of the information. I try to use
colors that are descriptive of the foliage
I'm painting, although I also keep mood
in mind. In general, I use a whole variety
of greens subdued and softened with the
inclusion of some reds to keep the greens
from overwhelming the painting.

Boats

Boats are common to most coastal
scenes, and even if they don't appear in
your subject, you may want to include
one or more. Boats can greatly add to
the mood of your painting. A lonely
beached boat presents a feeling of
solitude, while a string of boats dotting
a marina creates visual excitement.

But remember, boats come in all
sizes and styles, so make sure your
boat is appropriate for the location.
For example, on the Maine coast, the
lobster boat is most prevalent, along
with the small rowboat called a "skiff".
I generally try to show a boat from a
three-quarter view because this offers
the viewer more information about
the type of boat. However, this requires
a mastery of drawing and perspective

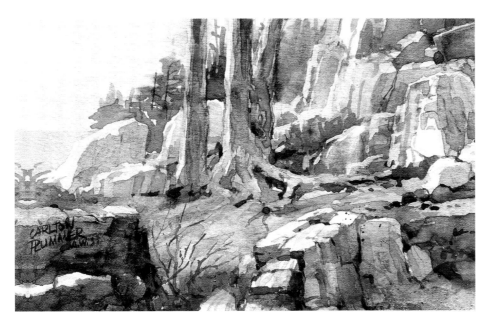

Sunlit Rocks, 4½ x 5½" (12 x 14cm)
To achieve the brilliant sunshine in this miniature, I used a variety of warm colors in a high key with contrasting cool red and blue-violets for shadows. The green silhouette makes a good backdrop for the trees that serve as the focal area. Notice how both of these masses of vegetation contain just enough detail to hint at the specific tree types without getting too fussy or overdone.

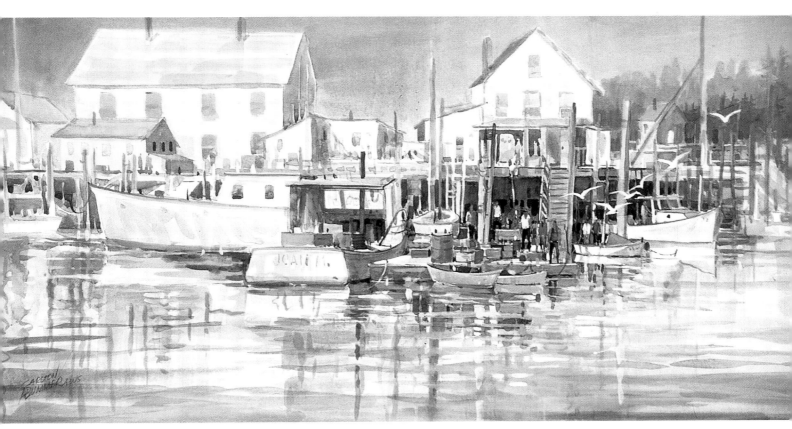

Early Light at South Bristol, Maine, 22 x 28" (56 x 71cm)
I did the original study for this painting from my boat while moored temporarily in the harbor. I caught the early morning light on the building and boats by carving around them with a wash of Cerulean Blue. I then applied a deeper blue-green tone with more pigment for the trees in the distance. The waterway was done wet-into-wet but finished wet-on-dry, using a combination of horizontal and vertical strokes to capture the reflections and gentle movement of the water. I pulled out highlights while the paint was still damp. Much of the activity is suggested with loose brushwork.

On the Island, 20 x 30" (51 x 76cm)

As a result of working at high noon under direct sun, this became a high-key painting. I used a wet-into-wet approach for the light yellow-green grass area, working around all of the objects. To paint the realism of the objects and figures (which happen to be two of my sons and myself), I worked wet-on-dry, allowing layers to dry thoroughly before adding more in order to retain some crisper edges. I added the final dark tones and accents only after looking at the overall value pattern in the composition.

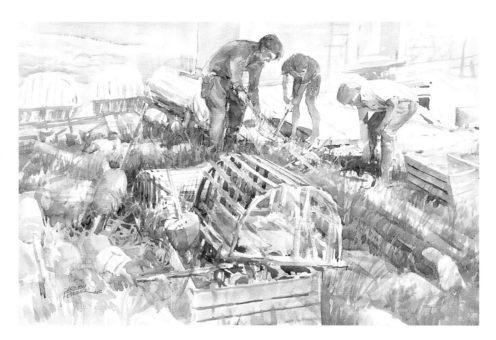

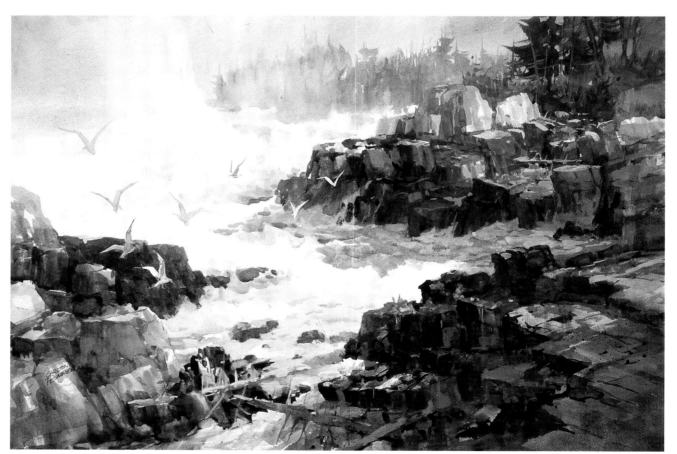

Inlet Surf, 21 x 29" (54 x 74cm)

I am known for painting the surf — in fact, this surf painting was commissioned for a series of ads on painting on illustration board. As often as I've painted it, I've never found a better way to capture the white, spraying foam than to paint around the white of the paper. With careful applications of paint elsewhere, either wet-into-wet or wet-on-dry, I can create a flow-through shape out of the whites that leads your eye into and around the painting.

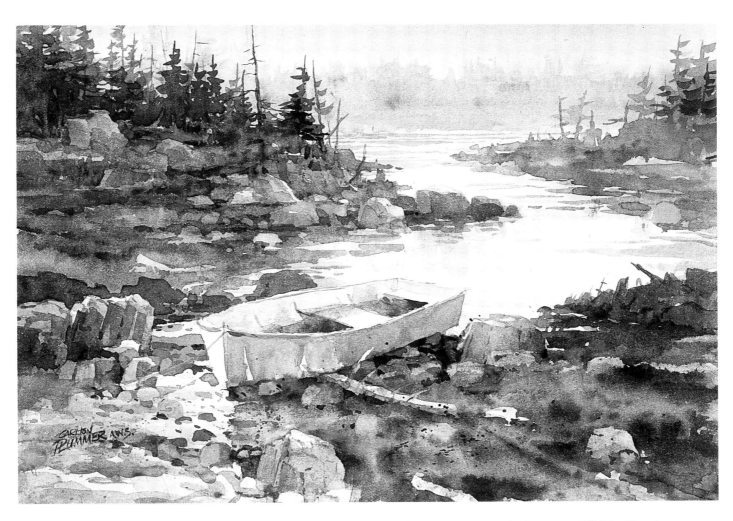

skills in order to get the shape and angles of the boat correct and to make it appear to be moving back at an angle.

When analyzed, boats are quite simple to paint, especially when shown in strong light because the value contrast between the lit side and the shaded side (as well as the contrast of the boat against the background) provides the viewer with a lot of information. If your point of view is looking down into the boat, be sure to use two or three differing values to define some of the objects and cast shadows within the boat, such as the seat, oars or gas can. When the boat lies at a distance, be sure to use value contrast to show the cast shadows, reflections and soft edges that will make the boat appear to be either floating, partially submerged in the water, or beached on dry land. Busy detail won't help you describe a boat, but the careful use of tonal values will

go far in convincing your viewer to perceive the object as a specific, three-dimensional watercraft.

Buildings

Buildings in coastal situations can vary greatly depending on the country, but all seem to have a special charm of their own. Whether painted fully lit or cast as silhouettes, harbor buildings make great backdrops for boats and figures. They provide wonderful geometric shapes that contrast against the organic shapes of the water, land and sky.

Painting buildings can be a bit of a challenge. The combination of boats, buildings, figures and reflections on the water presents a maze of shapes and colors that will require your full attention. I usually try to paint the overall effect without getting bogged down in too much detail. Once again, it pays to make small studies before committing yourself

Inlet Boat, 11 x 15" (33 x 38cm)
I was interested in creating a mood of solitude in this painting, so I used an atmospheric effect and a lonely boat to set the tone. See how the boat, abandoned in the low-tide inlet that calmly meanders into the misty silhouette, contributes to the mood? I kept the colors very muted, and built them up in light washes until the desired value and mood were established. Only a few dark accents were needed to accentuate the drama of the painting.

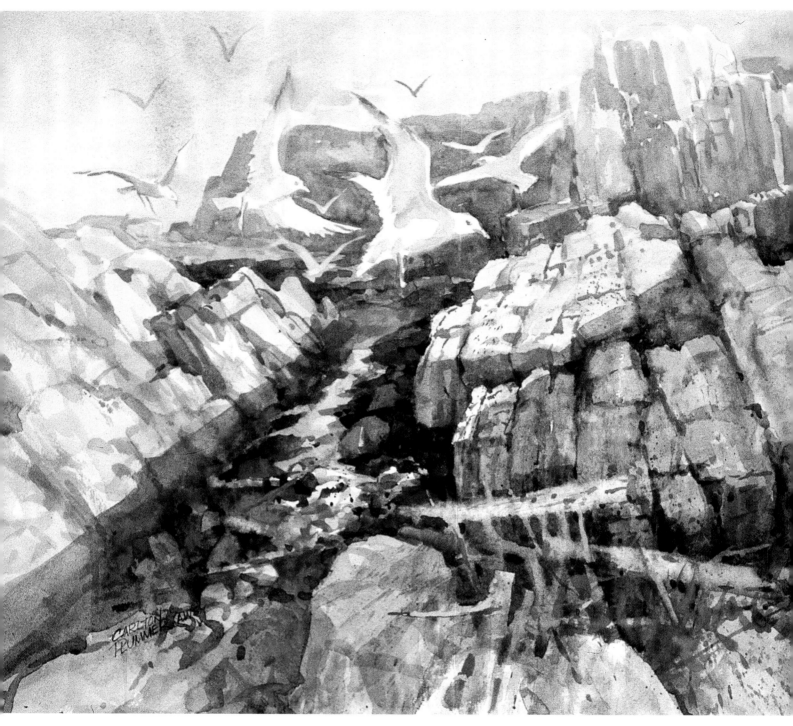

Gulls and Ledges, 15 x 22" (38 x 56cm)
Because this painting offers a closer view of the gulls, making them
more important as the subject matter, more detail was required in
the birds as they were silhouetted against ledges. I carved out the
cool around them and then came back into the wings and bodies
with tints of warm tones to denote form.

Surf Lights, **15 x 22" (38 x 56cm)**
I started this surf painting on location but didn't get too far along. Back at the studio, I improvised, turning it into something quite different. I was taken by this feeling about bouncing surf light that would occupy most of the water area, so I preserved plenty of white paper. I worked wet-into-wet for my soft edges and wet-on-dry for a crisp edge here and there for contrast. By repeating whites and light colors throughout the painting, I was able to guide your eye where I wanted it to go.

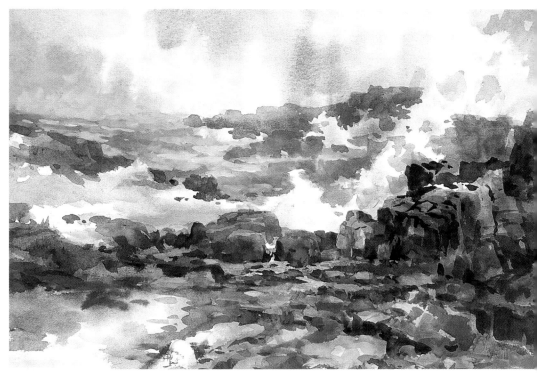

to a painting. Keep in mind that the standard rules of perspective apply here, as does the warm light/cool shadows or cool light/warm shadows rule for painting objects in sunlight.

When seen slightly closer up, these outdoor buildings often have an aged, personal character. It's just what you'd find in a mature human being, although in humans, we call this character wrinkles! Painting buildings is a good time to use those techniques for creating weathered textures.

The interiors can also be interesting to paint. I found the fish houses on Stuart Island, New Zealand, similar to those of Maine with a bit more personal coloring. The coastal buildings in Alaska were more worn and duller in color but had an interesting, tattered look.

When Joan and I travel to any faraway place, we try to sketch, photograph and paint as many small studies as time allows. Each trip is really a working vacation where we feel an obligation to garner as much information as we can, knowing we may not return to this particular locale. Our sketchbooks, photo albums and paintings present a varied travel log. On returning to our beloved Maine coast retreat, we often ask ourselves, "Why did we leave this place?" The answer to that is always to further enrich our lives and to expand our horizons, as I hope this book on marine painting is doing for you.

Discover the secrets of bringing figures into your coastal subjects.
They'll add charm, drama and interest.

Including the figure in the coastal environment

As an artist working on location, you will encounter wonderful situations involving people doing their thing. Some are workers, while others are just enjoying nature or water-related sports. They come in all forms and ages, from young children playing in the sand to mature people strolling along piers. I often go out of my way to include figures in my coastal scenes because they bring a certain charm and special interest to an otherwise ordinary scene.

From a technical standpoint, figures can be used to generate a focal area or simply to spice up a less important area. Sometimes they occupy a large space, making a very dramatic statement as a portrait. Other times, they become lost in the scene, waiting to be discovered.

Distinguishing distant figures
Figures seen from a distance are generally presented as simplified silhouettes with little detail, but there's no reason for these small additions to be dull or boring. Think of how much action and movement you could contribute to your painting, just by suggesting the movements of real people — a lobsterman working on his boat, a young boy foraging for treasures in the sand or a couple leisurely walking along the water's edge. With some close observation, you can discover the telltale signs that will make your simplified strokes "read" as specific figures with a story to tell.

First of all, the gesture or the stance of the figure reveals a lot about the activity. The position of limbs and body movements can make the difference between a fisherman hauling in a net or a clam digger bent over his work. Color is also important — drab colors probably suggest a worker, whereas bright colors are more typical of people at play. And all of these characters come with their own "props". The lobsterman has his boat, traps and bait buckets, and the sunbather has her umbrella and beach chair.

Sometimes figures are seen in groups, and here again their gestures and the proximity of the figures will reveal whether they are talking (or "jawing" as they say in Maine), working together or not related but simply inhabiting the same space. These groups make great additions to a composition because of their overlapping shapes, cast shadows and interesting silhouettes.

Drawing the figure with a brush
A small figure can be painted as a silhouette, using one color and just a few brush strokes, perhaps even in one stroke without ever taking the brush off the paper. It takes practice in learning to load up the brush and lay down the gesture in one or two strokes, but things that are worthwhile always do.

In order to paint one- or two-stroke figures well, you have to be as comfortable with drawing with the

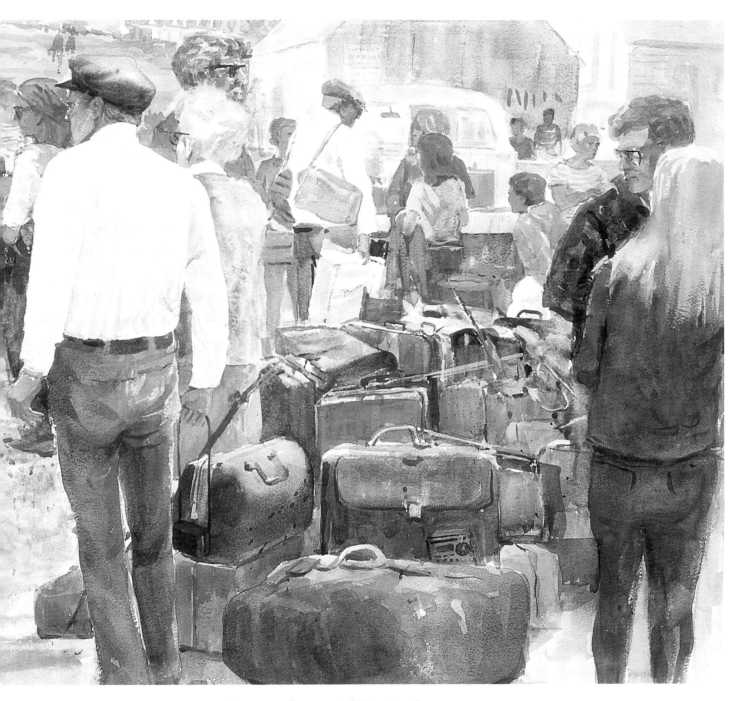

Monhegan Landing, **22 x 30" (56 x 76cm)**
Monhegan Island is a busy place during the summer months, attracting
tourists and artists from everywhere. Arriving at the boat landing, these figures
formed a horizontal movement, separated at one point by a collection of
baggage that created a diagonal wedge. Together they formed a powerful
axial design, with the man in the white shirt acting as the focal point.

"From a technical standpoint, figures can be used to generate a focal area or simply to spice up a less important area."

brush as you are with a pen or pencil. If your brush-drawing skills are limited, I suggest you start taking a sketchpad with you more often and doing lots of quick doodles of people just being people. Once you've improved, you'll find your ability to incorporate figures quite gratifying and very useful as an important part of your painting repertoire. Although much of your sketching will still be done with soft pencils and pens, you'll find using a brush even more fun, once you get used to the flexibility.

Allowing the figure to dominate

Of course, as your figures move into the foreground, getting closer to the viewer, you will need to add more details. You may need to use more strokes of tonal or color variations to show the lit side and the shadowed side of each body and to distinguish between hair, face and clothing. And if you decide to make your figure a very central, dominant element in the scene, you will have to use all of the usual techniques of value and color to reveal the person's three-dimensional forms.

If you're going to make the figures a more dominant part of your composition, you'll also have to consider more carefully how they will influence the overall composition. Remember to use the shape of the figure or figures as part of the structural design of your image. Then determine how the shape should relate to the other shapes. If it's a less important shape, it may need softer edges and more subdued colors; if it's quite prominent, its edges should be crisp and well-defined, it should probably have strong value contrast and its colors may need to be repeated elsewhere in the composition to help the figure or figures fit in.

Study this little collection of figurative paintings to see the many ways figures can contribute to a painting.

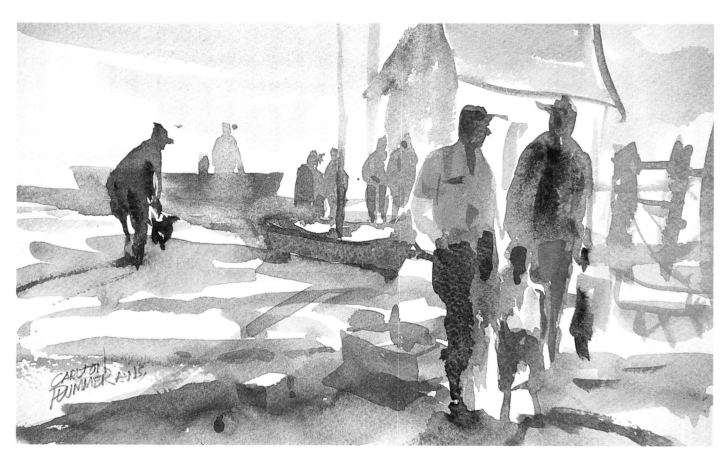

Ebbtide Activity, 11 x 15" (28 x 38cm)
These figures are good examples of quick brushstrokes applied directly on paper without drawing with a pencil. I tried to make each whole silhouette with one color to set up the gesture of the pose, then added a variety of other colors while the shape was still wet so the pigments would flow, creating a unified figure head to toe.

Gallery of figurative paintings

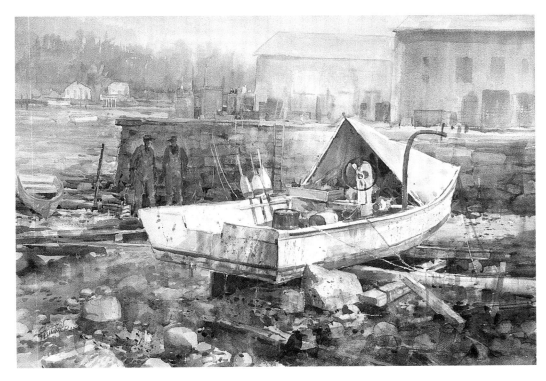

Ready for Action,
15 x 22" (38 x 56cm)
In this case, figures are being used to add interest instead of being the main feature. You discover the lobstermen figures blending into the wharf area only after looking at and then beyond the lobster boat, which is the focal area. I blurred their edges and kept their values close in relationship to the surrounding area so that they would not grab your attention but rather reveal themselves to you gradually.

Beach Figures,
11 x 17" (28 x 44cm)
A few direct brushstrokes can create the illusion of human activity. Without fanfare, I quickly established the silhouette to state the true gesture and form of the figure, then moved on.

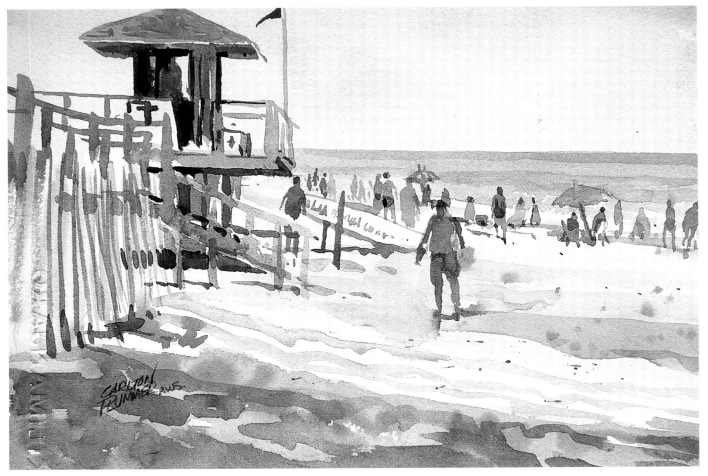

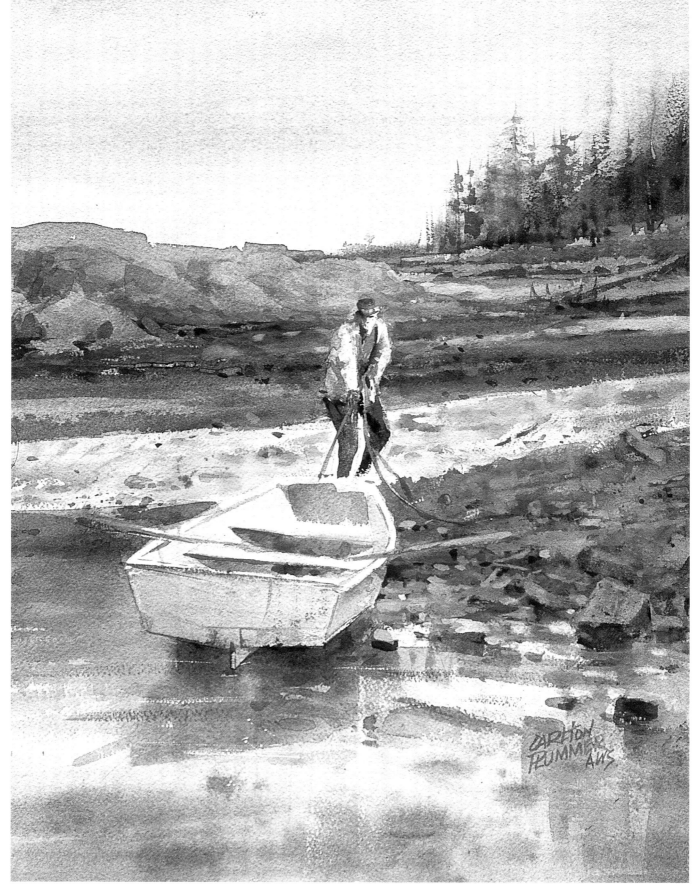

Landing on Outer Heron Island, Maine, 22 x 15" (56 x 38cm)
I am always amazed at the impact even a single figure can have on a painting. Here, the young, lone explorer landing on a wilderness island early in the morning not only sets the mood of the painting but also helps to unify the composition based on diagonal patterns of lights and darks. I painted the shapes around the figure, leaving the area of the white shirt dry to retain sharp edges. The head is in partial shade, so the values there had to be closely related.

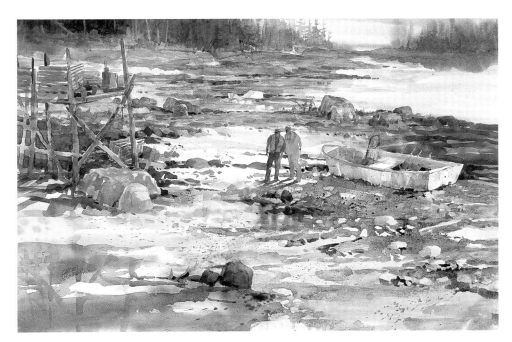

Lobster Bait,
22 x 30" (56 x 76cm)
Looking down onto the scene offered me an unusual point of view for subjects like this. The lobsterman, Larry, was using my wharf to shovel herring into buckets for lobster bait. My son, Gerry, who was 14 at the time, was looking on. I painted these figures wet-on-dry with some glazing and loose brushwork. Later, I used some gouache on the oil skins that Larry is wearing to "beef up" their visual weight.

Fishermen's Conversation, **15 x 22" (38 x 56cm)**
Although these two fishermen are comparatively small in the composition, they carry a lot of weight with their colorful silhouettes against the low tide sand. Standing by the boat, they form a well composed unit as the focal point. To give the illusion of the gesture of the figures, I had to simplify and clarify the shapes in a silhouette, using direct brush work. I kept the values closely related (same value, different color) to maintain the feeling of a distant silhouette. Painting in their cast shadows and reflections helped to integrate the figures into the composition.

> **"Figures seen from a distance are generally presented as simplified silhouettes with little detail, but there's no reason for these small additions to be dull or boring."**

Greek Isle Figures,
22 x 15" (56 x 38cm)
This painting shows the quick brush stroke figures at their best, especially the smaller, more distant figures as they proceed up the hill. I painted them without lifting my brush off the paper, not stopping until I had established the basic silhouette of each. While the first applications were still wet, I applied the variety of colors needed to suggest clothing and other details.

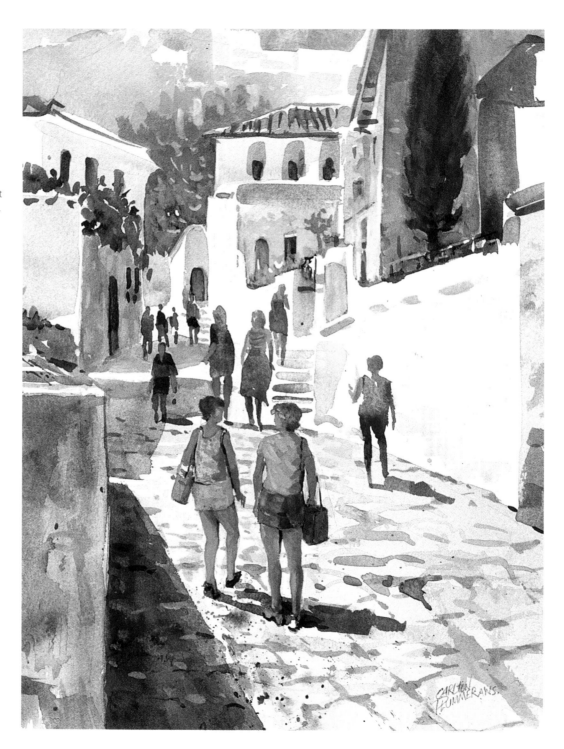

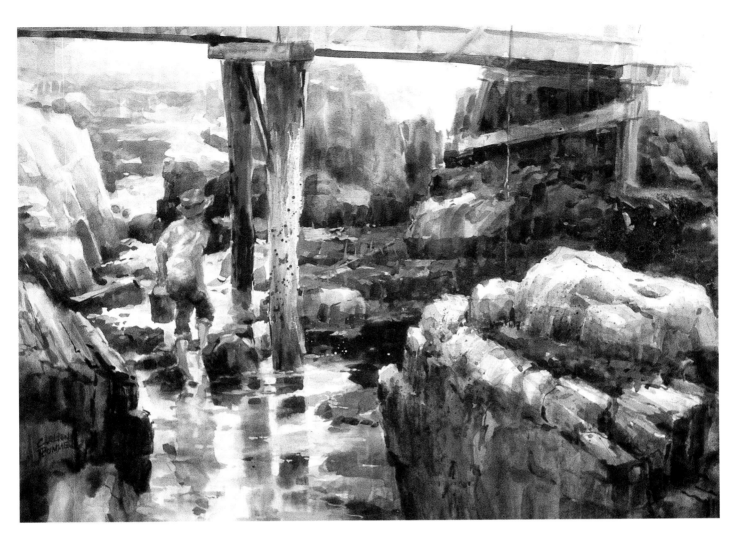

Ebb Tide Explorer, 20 x 30" (51 x 76cm)
This wharf with pilings at ebb tide made a dramatic setting for our little explorer. Although he becomes the focal point near the pilings reflected in the tidal water, he is a subtle shape that almost blends into his environment. I painted his shirt light blue so that he would have some note of color contrast against all of the earthy colors.

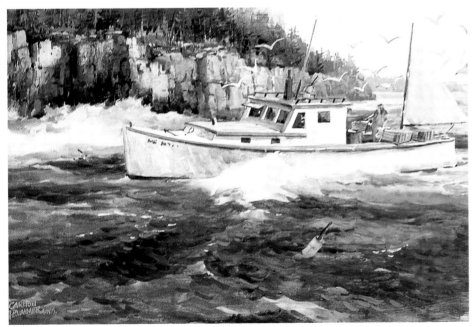

Lobstering In Close,
11 x 15" (28 x 38cm)
The lobster boat catching the sunlight as it comes in close to the island ledges is a familiar scene along the coast of Maine. Here, the lobsterman is an integral part of the unit made up of the trap and stern sail. Although the figure is small and lacks detail, the gesture of the silhouette and the bright yellow of his oil skins allow us to identify him and his activity.

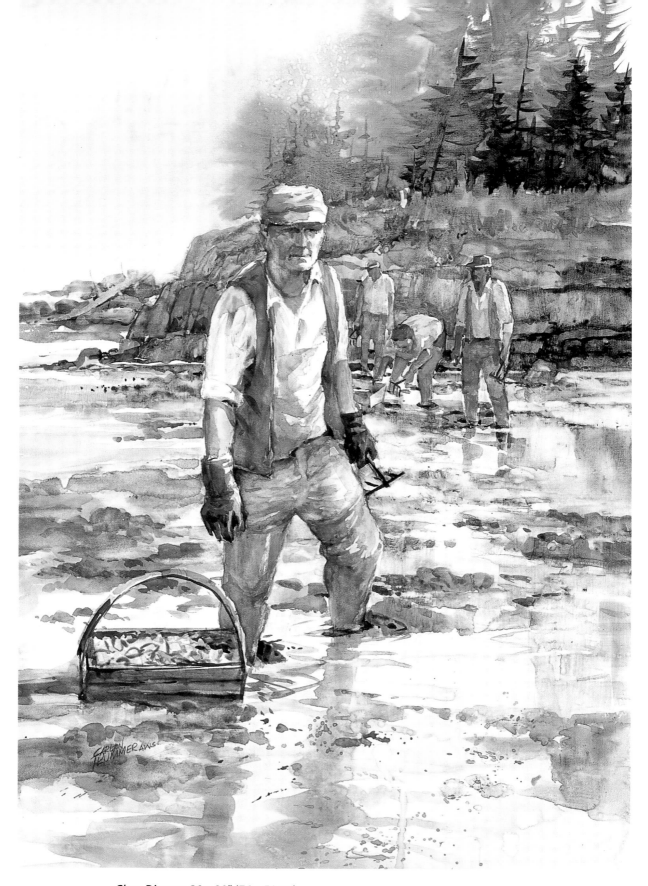

Clam Diggers, **30 x 20" (76 x 51cm)**

This painting is the result of small studies and sketches done on location. I wallowed in deep mud in the clam flats in a secluded inlet one day just to photograph this 16-year-old clam digger. I paid him to pose for me, and he must have thought I was a bit balmy. Later, when I painted this painting, I dressed him to suit my needs and transposed him into an older man. I painted the figure wet-into-wet, and came in with shadows and accents before the paint dried. I then painted around the shapes to retain the light values of the clothing.

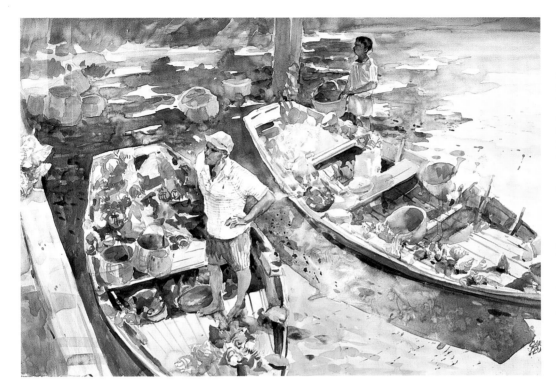

Haitian Light,
22 x 28" (56 x 71cm)
The figures in this painting were done in different ways, depending on their lighting. The distant figures in the dappled shade of the palm trees were treated as silhouettes, using similar colors and values of the area to keep them in the background. The young boy to the right had more light on him, which required more contrast but with a tone over most of his body. The main figure as the focal area in the foreground required more attention and care. I painted the red-violet shadows in a wet-on-dry wash around the top part of the sunlit figure, leaving his shirt white. I then came back into the figure wet-on-dry with light color to retain the contrast from the sun.

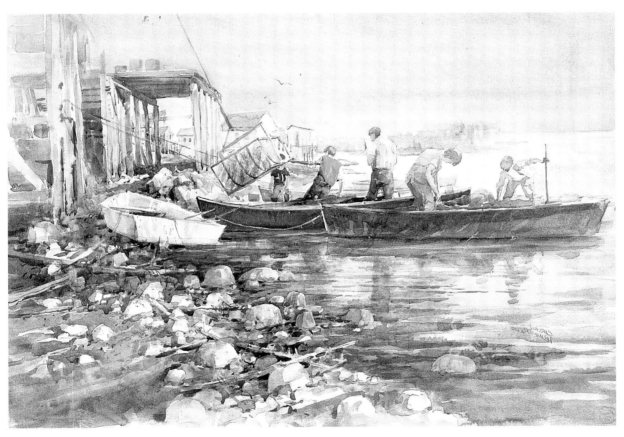

Unloading Sea Moss, 20 x 30" (51 x 76cm)
Although these figures are basically silhouetted against the light and take on a variety of gestural positions, I had to treat them with more care because they are larger shapes within the composition. I worked wet-on-dry with watery washes, adding a few bright, warm colors for accents. A few well-placed dark accents on the figures gave them some dimension.

Let the coasts and waterways provide you with endless
inspiration in the form of found objects provided by both
Mother Nature and man.

Creating a coastal still life

The rugged, rock-bound coast of Maine
has been an inspiration for much of
my painting over the years, but that
inspiration is not limited strictly to the
genre of landscapes. Every artist with an
eye for promising subjects will find that
the paraphernalia and debris common
to all coasts and waterways can lead to
wonderful still lifes, already poised for
painting.

Composing a still life

While walking along the shore or
meandering through the tidal flats,
I find that Mother Nature often
contributes her share of natural debris
such as rotted tree trunks and limbs,
sometimes covered with seaweed.
Driftwood comes in all sizes and unusual
shapes, like dramatic pieces of sculpture
bleached to a silvery, smooth patina
from the sun and sea. Skeletons of sea
life and seashells mixed in with the kelp
and other items provide a visual delight,
especially illuminated by the sun.

Man contributes to these found-
object still lifes as well, everything
from pot buoys to rope. For me, the

shore easily becomes a fantasy land
when I'm looking for something
unusual to paint.

With the right lighting from "old sol",
the arrangement comes to life, casting
exciting shadows on the surrounding
ledges or sand. Quite often, there is no
need to rearrange the items in a found-
object still life. However, this is a good
time to use a viewfinder — a rectangular
opening in a piece of cardboard — to
help choose the best angle, viewpoint
and cropping for the ready-made
composition. I recommend looking for
one object, such as a piece of driftwood
or string of kelp, to serve as the "flow-
through shape" that links the design.

Still, because you are working
outdoors where physical conditions are
constantly changing, it is important to
work fast. Take a few photos while the
light is right and do a sketch or two
before you paint a small watercolor. In
an hour, the light will be totally different
and the tide may be covering up what
you wanted to paint. This is what we
have to tolerate when painting on
location along the coast.

Winter Still Life, 22 x 30" (56 x 76cm)
It is always interesting to see how snow creates lost and found edges. Here,
the shrouded forms interact with the sunlit gear to form a very cohesive
composition. The diagonals are at work, coming together to form a focal
point by the yellow-green barrel. The flow-through pattern of snow moves
into the middle of the composition but the two barrels are connected
visually by soft, muted tones. In the background, I suggested subtle vertical
shapes for atmosphere. It is truly all about sunlight.

Discovering interiors

I discovered yet another alternative coastal painting experience years ago when I realized I could paint the interiors of old lobster sheds, warehouses and fishing shacks filled with heaps of interesting objects and gear. I could take any portion of this assemblage of assorted items and come up with a different idea each time.

When painting interiors, you'll find that color is not as important as value. Without the direct sunlight, the color is somewhat limited, so you'll have to rely primarily on a range of tonal values to evoke drama and excitement in your composition.

Still life and interior paintings, especially when done on location, will provide diversity from doing landscapes and seascapes. They provide another avenue of expressing emotion and drama in a variety of ways without being contrived. Remember, it's not what you paint, but what you bring to the painting and how you choose to interpret the subject matter that will take your work to another level.

Dingle Peninsula, Ireland,
11 x 15" (28 x 38cm)
It's always interesting to see the variations in boats around the world. In this composition, I placed the boat so it would occupy most of the painting. The deep tones of the rocks contrast against the boat.

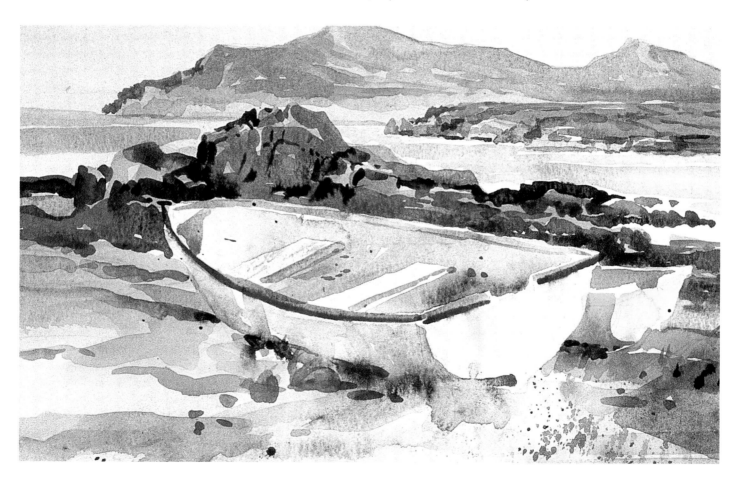

Nautical Gear, **30 x 22" (76 x 56cm)**
Sometimes we get lucky, as I did here, and discover a ready-made set-up that needs very little adjustment. It also lent itself to a vertical with the lobster gear squeezed in between traps and the fish house. The darks were aggregated to add drama.

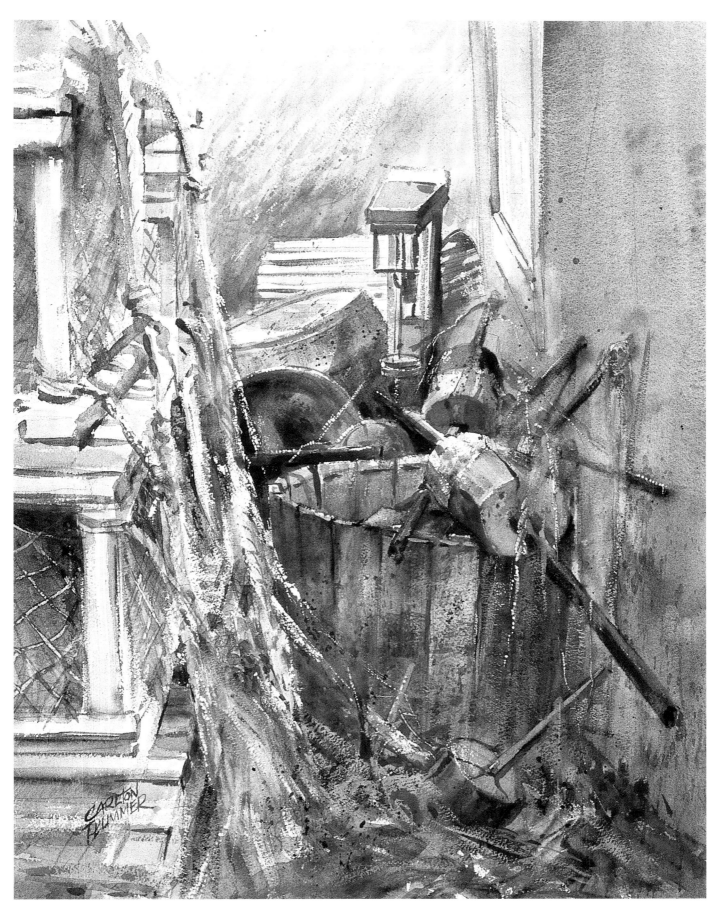

Coastal Still Life, 15 x 22" (38 x 56cm)
The lobster traps serve as a natural still life in the immediate foreground of an inlet scene. The wharf and building run off the paper and act as a backdrop for the traps. This was another found object still life waiting to be painted.

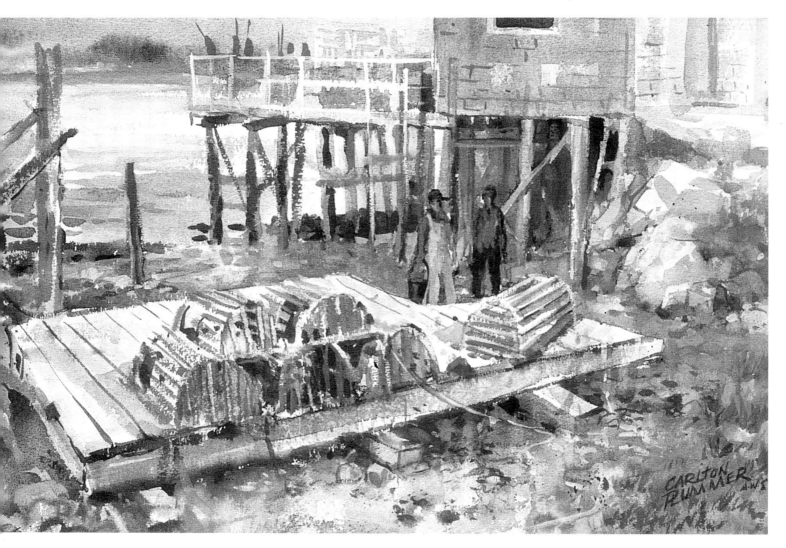

Driftwood Still Life, 20 x 30" (51 x 76cm)
I found this driftwood forming diagonals as they intersected in a tight mass. Notice how I then painted the rocks to form a crisscrossing with the driftwood. The deeper-toned seaweed around the rocks and logs adds contrast and helps to hold the composition together.

Coastal Debris,
15 x 22" (38 x 56cm)
The broken gangway washed up
on the shore provides a strong
diagonal, emphasized by the dark
tones around it. The background
is lost into a mist, forcing your
attention to the man-made
structure. Except for the misty
background, I painted wet-on-dry.

"Every artist with an eye for promising subjects will find that the paraphernalia and debris common to all coasts and waterways can lead to wonderful still lifes, already poised for painting."

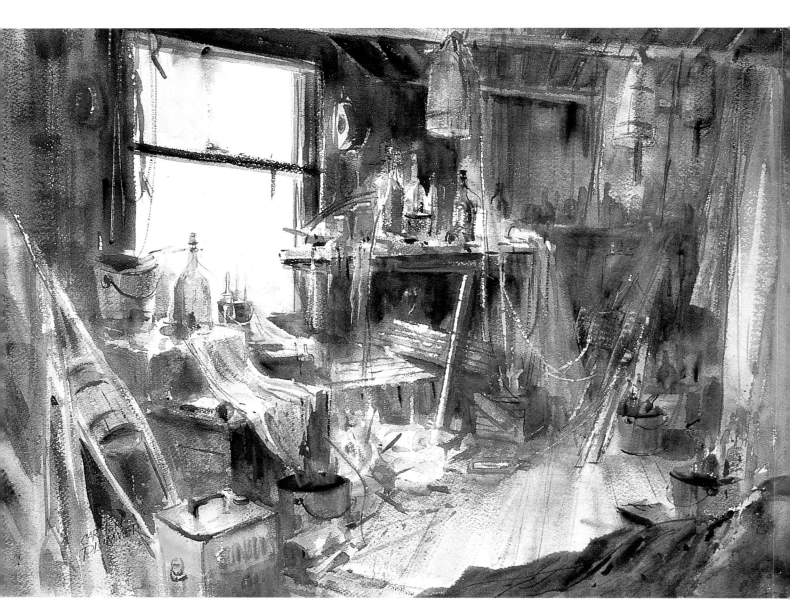

Lobster Shack Interior, 22 x 30" (56 x 76cm)
This interior represents a mysterious, fairly low-key interior, complete with still life objects. Objects close in by the light source catch the light, but other shapes away from the light become blurred into the darkness, resulting in a dramatic composition. My initial washes were wet-into-wet to maintain the continuity of a low-key mood. I painted late on a foggy evening, although I could hardly see my pigments.

Waterfront Silhouettes,
21 x 28" (54 x 71cm)
This painting depicts a low light with strong contrast, typical of late day lighting. To begin with the sky and background, I painted very wet-into-wet to create soft edges that would suggest distance. I treated most of the objects as dark silhouettes to emphasize the drama of the lighting. Finally, I used wet-on-dry, drybrushing and spattering techniques to render some texture.

Ocean Island, 15 x 22" (38 x 56cm)
Another visit to my favorite painting spot on Ocean Island revealed the wildness and richness of coastal vegetation and driftwood. I especially was inspired by the way the undulating ground leads your eye diagonally to a lonely silhouetted group of evergreens. I worked wet-into-wet initially, followed with wet-on-dry. The deep mauve tones add depth to the vegetation and rocks.

Conclusion

As we move along a variety of pathways in life, changing directions for various reasons, we become the sum of our past experiences. Because of this, each one of us is a unique personality, wishing to express ourselves and to communicate these feelings to others. Some of us may find it difficult to express our feelings and ideas, depending on the culture and environment we've known since childhood, yet the desire remains in all of us.

As an educator, I feel I have a strong responsibility to inspire, inform and guide my students and readers, and by so doing, help artists learn to release their emotions visually. My point of view in this book is only one among many, but the underlying philosophy is the sum of my 45 years of teaching and painting. I'm confident that my concepts presented here can help you be more expressive.

This book, designed to instruct and pass on information that I've accumulated over years, also presents you with a challenge to go beyond conventional approaches, allowing for the watercolor medium to respond and often show you the way. This does not mean that you should throw out the rules and guidelines that will help you arrive at a higher level of competence; it simply means you may have to crawl before you walk. Once you know the basics, you can bend the rules and break the barriers, widening the avenue for expressing your inner self, just as I've done in many of these favorites shown in this gallery section.

Although I have used a fairly realistic approach to depict various nautical or marine scenes, with drama as my ultimate goal, this break-down of my basic philosophy can be applied to any subject or style, including abstraction. There is a wide window between super-realism and abstraction. Emotional and intellectual conclusions temper what the artist perceives. Basic design principles are available to facilitate building a compelling image. It's these design structures that form the basis of our visual expression.

The various painting demonstrations in this book are just a small sampling of limitless possibilities at your disposal. So take what you need and apply the information in your own way to your work. Realize who you are and decide on how you want to express your ideas. The uniqueness in each of us is very important. There is plenty of room in the art world for another individualized style or point of view!

Once you have fortified yourself with information and some basic skills, try to find time to commit to your art. Let your passion for expression guide you as to how much time you devote to painting. It may be only a part-time commitment, but it can still be an important part of your life. Keep your priorities in order and you'll always find the time to paint.

Finally, try to set goals for yourself. Hard work and determination pay off. As the saying goes, no pain, no gain. Painting can be fun and fulfilling, but there may be times when it will be frustrating. The good news is that it is only a piece of paper. If you're not happy with your efforts, give it another shot! Enjoy the journey. Some say it is more important than the destination!

So, I'll see you on the coasts and waterways. Happy painting!

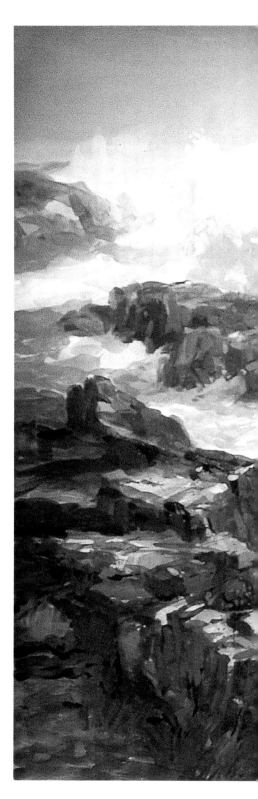

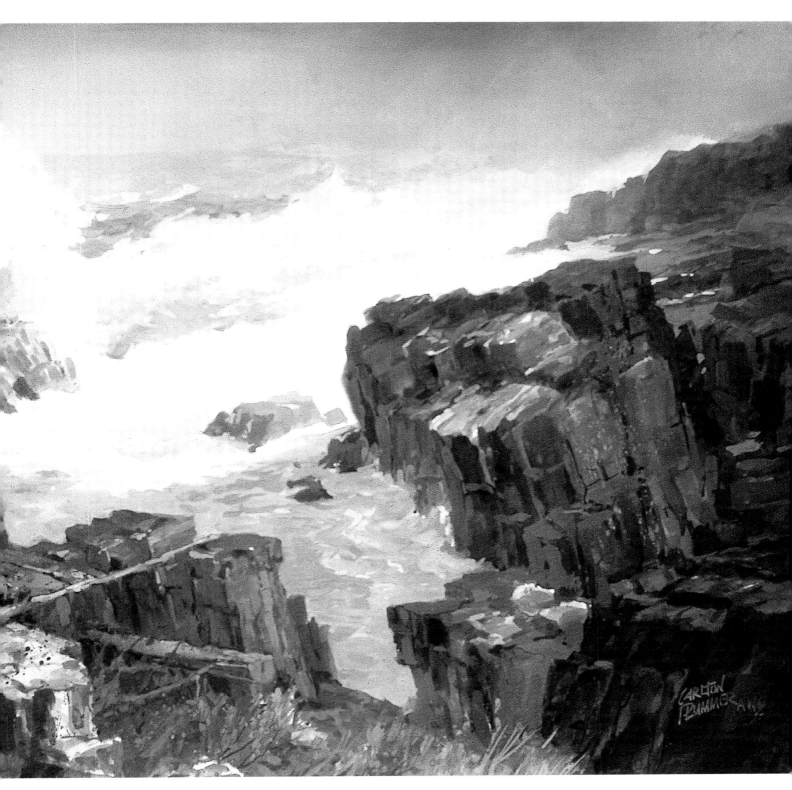

Surf Glow, 15 x 22" (38 x 56cm)
This painting is all about the dramatic action of the water. Notice how the white area of the surf is broken into an interesting shape. I carved out the surf area with my sky tone and threw in some large middle tones for the ledges to lay out the basic approach to the design. It was important to keep most of the painting low in value to bring out the contrast of the surface.

A selection of coastal scenes for you to study. Draw on all the
information given previously and try to identify the tactics I used.

The drama of the coast

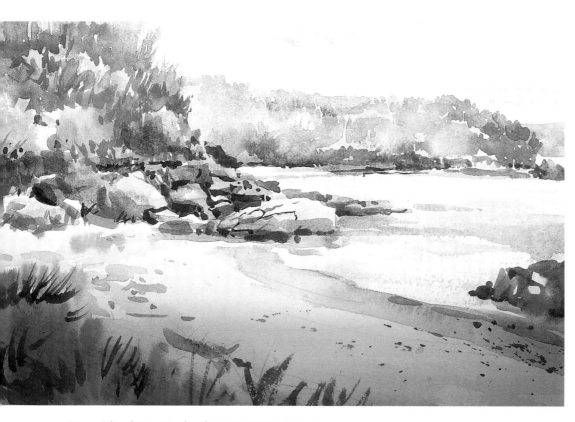

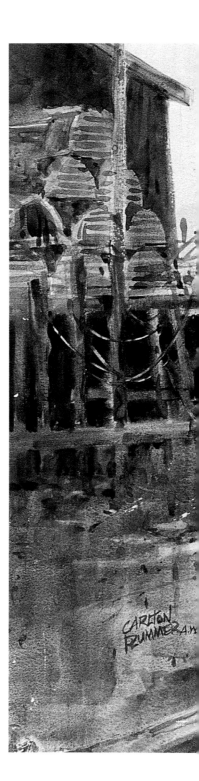

***Stuart Island**, New Zealand, 11 x 15" (28 x 38cm)*
This is the remote, southern-most part of New Zealand. No cars are allowed
on this small island, making it difficult to explore. This beach scene shows
the thick, tropical vegetation that grows down to the rocks and water.

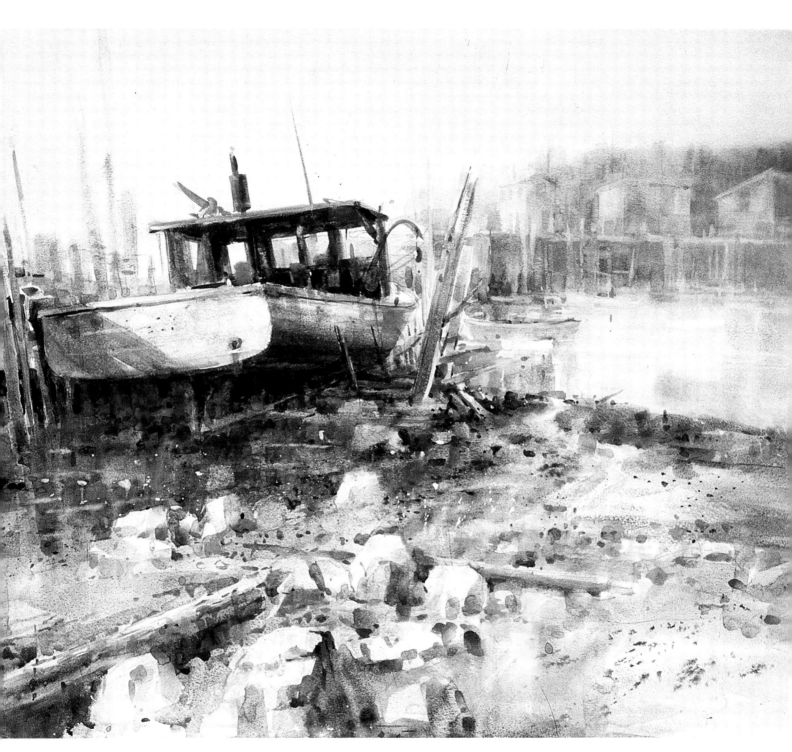

Port Clyde Waterfront, 30 x 40" (76 x 102cm)

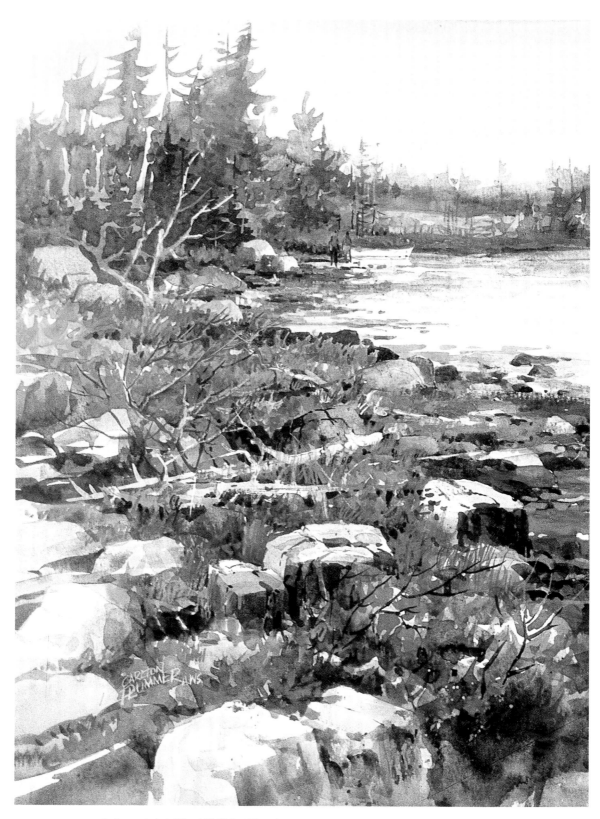

Autumn Inlet, **22 x 15" (56 x 38cm)**
The diagonal comes in handy when you need to pull together a vertical composition such
as this. It's a matter of utilizing vertical tie-ins and repetition of color and value from bottom
to top to force the eye to track up and down. The ground cover between the diagonally
placed rocks acts as a flow-through pattern back into the composition. Notice how the
texture of the vegetation is more obvious in the foreground to give a feeling of depth.

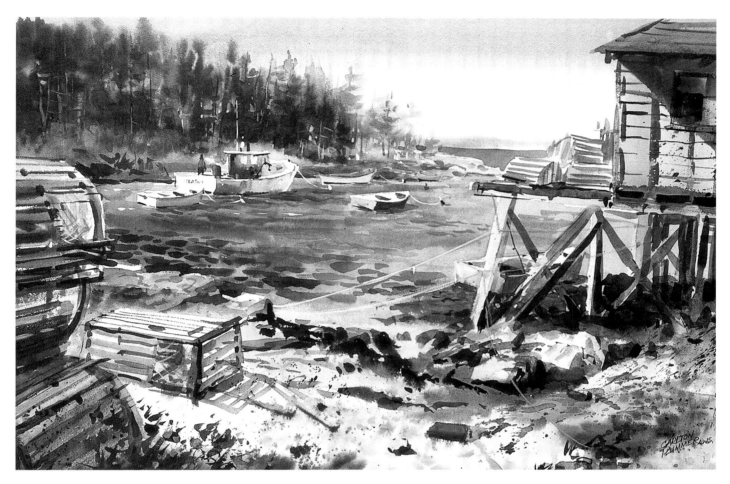

West Point, Maine, 28 x 36" (71 x 92cm)
The building and traps point in from the sidelines and provide us with a view of the lobster boat moored against a silhouette of trees on a headland. All angles point inward to the focal area. This was painted on illustration board, mostly wet-on-dry. The colors are bright and the shadows deep to show the brightness of the day.

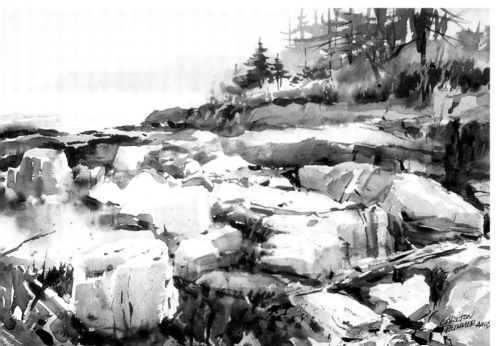

**Tidal Illumination,
15 x 22" (38 x 56cm)**
I left much of the white paper to represent the light on the top side of the rocks and the tide pool water. Darker toned rocks make lighter rocks stand out. I used the negative-positive approach to show debris and other light objects by painting around the objects with darker colors, leaving the white of the paper. Shapes in the background were simplified to show distance.

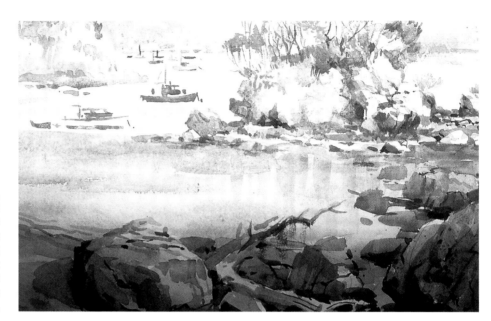

Harbor on Stuart Island, New Zealand,
11 x 15" (28 x 38cm)
The scenery, although lush, seemed to take on a lightness, perhaps due to the atmosphere of the region. I accented coral rock with darks to bring out the pastel tones. I painted directly without sketching with a pencil to save time. There were so many subjects to paint, I wanted to capture this subject and quickly move on.

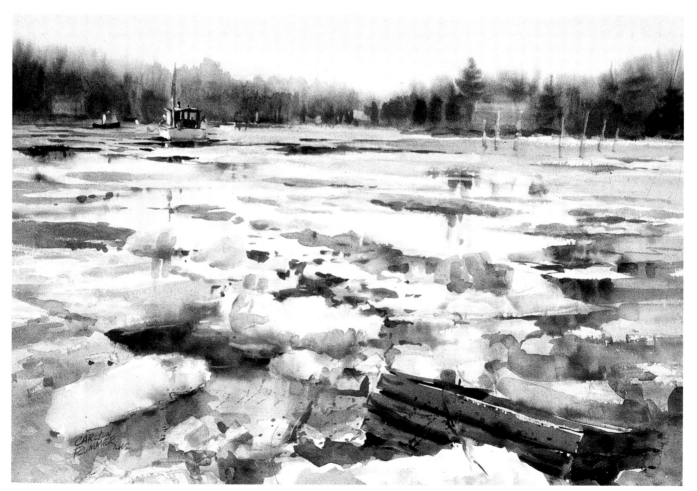

Ice Flow III, 20 x 30" (51 x 76cm)
One winter, this salt water inlet froze over. When lobstermen broke up the ice around their moorings, the pieces of ice formed interesting diagonals and contrasted with the open water. I painted the water wet-into-wet to create depth in the reflections. The ice shapes were done separately in analogous colors of blues and blue-greens to capture the cold feeling of the winter day. The warm glow of the sky adds a contrast to the coolness of the ice and water.

"Once you know the basics, you can bend the rules and break the barriers, widening the avenue for expressing your inner self."

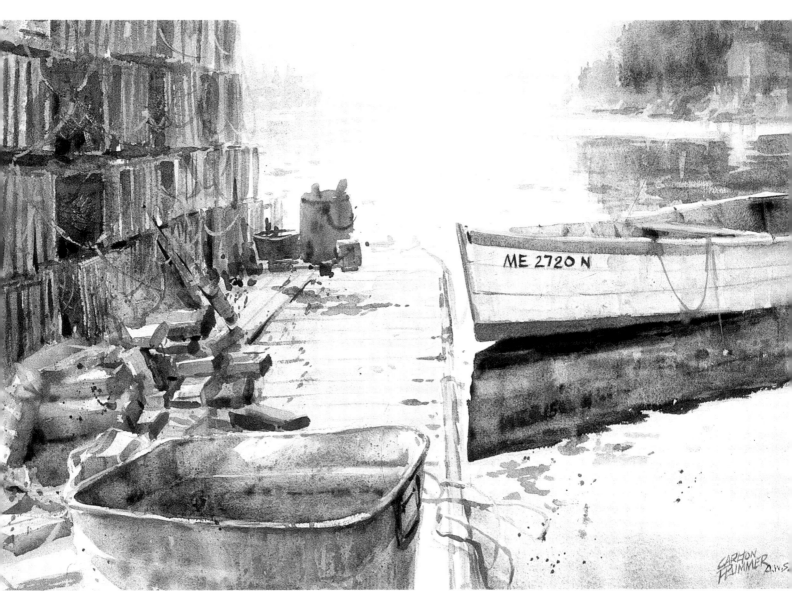

Inlet Reflections, 20 x 30" (51 x 76cm)
Thanks to the whiteness of my 140 lb cold-pressed paper, the transparent pigments were able to provide the clarity and luminosity needed to portray the placid, early morning mood.

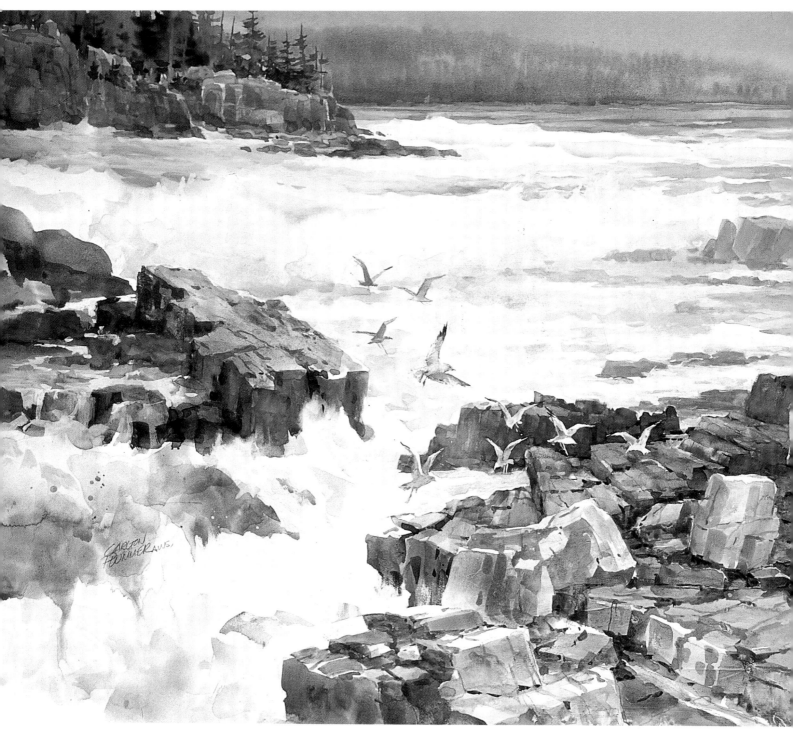

Gulls in The Surf, 22 x 30" (56 x 76cm)

This scene, based on an outdoor painting at Acadia National Park, shows surf as it rolls in on a rocky beach. The foreground water leads the eye inward along with the rocks. The sunlight controls the mood of this scene, which explains the lightness of the sea and the rocks. The warm yellowish oranges on the rocks are complemented by the mauve tones. The background is rendered in soft, muted tones to show the atmosphere and to focus more attention on the foreground, which leads your eye in.

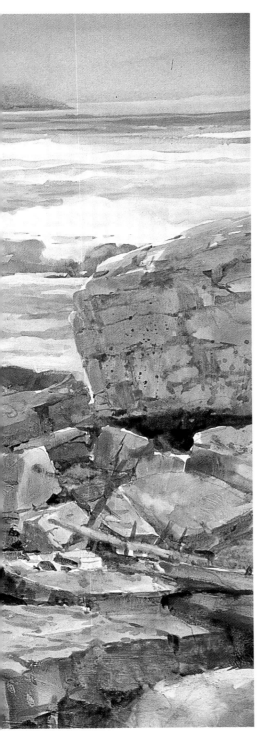

Cove Patterns, 15 x 22" (38 x 56cm)
This is a good example of simplifying the various elements into flattened out shapes. Even the textured grasses are stylized and flattened. The entire painting utilizes silhouettes as symbolized shapes woven together.

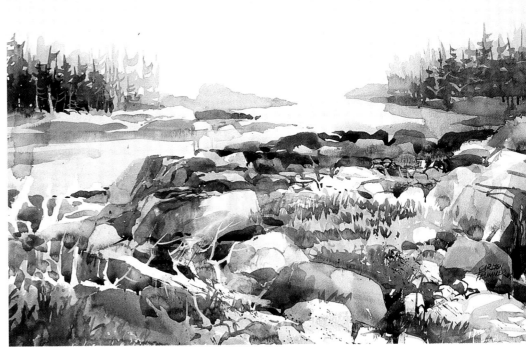

"Although I have used a fairly realistic approach to depict various nautical or marine scenes, with drama as my ultimate goal, this break-down of my basic philosophy can be applied to any subject or style, including abstraction."

Stuart Island Inlet, 11 x 15" (28 x 38cm)
Although the tropical growth was prevalent on the New Zealand coast, the buildings and boats pulled up on shore reminded me of my native state of Maine. Note how a few deep tones placed as accents give this high-key painting a more glowing effect and extra depth.

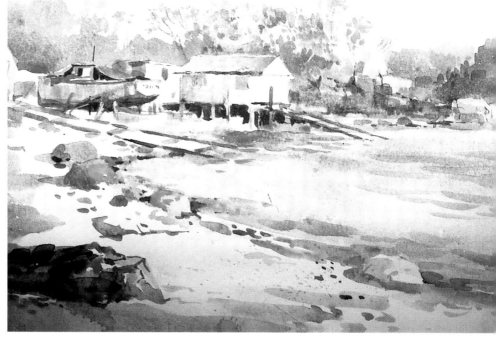

Foggy Mooring, 15 x 22" (38 x 56cm)
This high-key, strong contrast painting captures a foggy atmosphere with a minimum of effort. A few light washes suggest the mist and mass. The dark accents of the boat reflections form the basic structure of the painting, enough to communicate the mood. The silhouette of the figure and cabin interior is the focal area because of the strong contrast and placement in the composition.

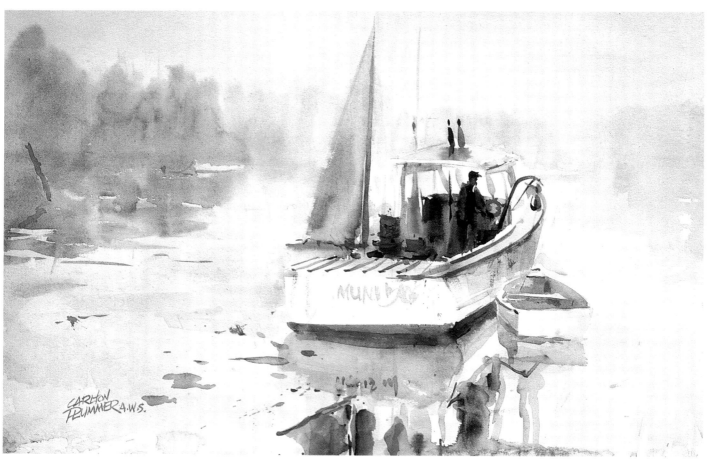

Winter Surf, **20 x 30" (51 x 76cm)**
This is an imaginary painting where I tried to show the fury of a coastal winter storm. I felt the diagonals would evoke a feeling of energy and movement. They certainly direct the eye to the active area that forms the focal point. Large areas of white paper represent snow-clad ledges. The wet-into-wet sky area was left white to show the surf.

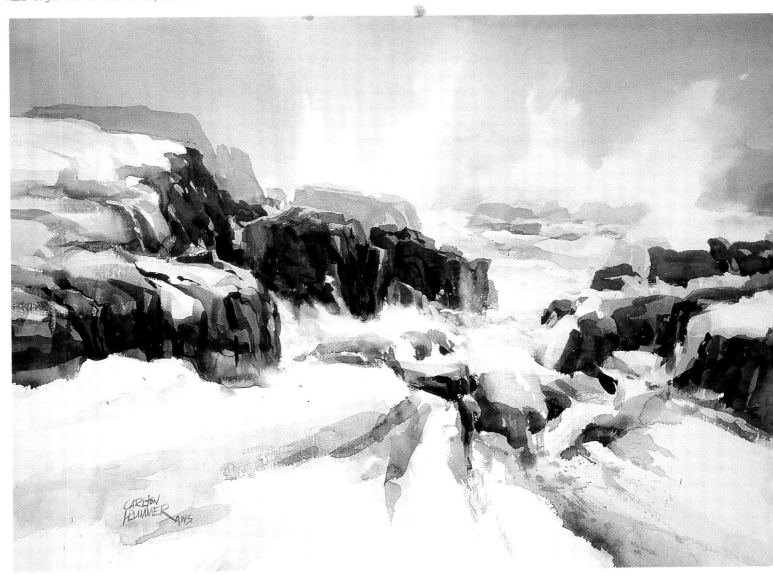

"Quite often, the sky is the determining element in the painting. The lighting conditions and the weather, both indicated in the sky, influence the colors and tonal values that create the mood and emotion in a painting."

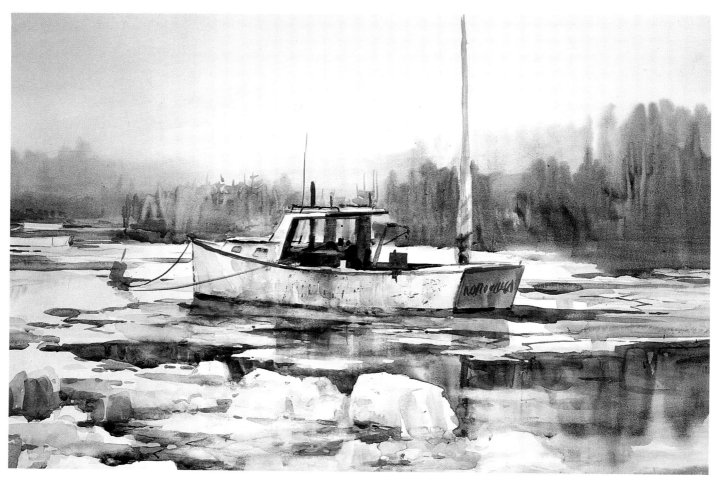

Ice Flow, 20 x 30" (51 x 76cm)

I painted this one on an illustration board, which is a rather smooth, slick surface that allowed me to manipulate the paint and lift it after it had dried. This proved to be an asset to me because of the complexity of the ice and open water, a true test of my skills. I kept pretty much to the cool blues to create the mood.

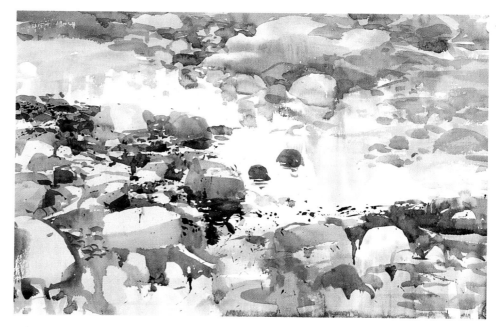

Tidal Reflections, 15 x 22" (38 x 56cm)

Demonstrating for one of my location workshops in Maine, I began by brushing large areas of warm and cool colors wet-into-wet on the paper, leaving white paper for tide pools and contrasting rocks. I then painted the darker rocks directly over these areas. On the tide pools that had been left as white paper, I applied very light blue washes and subtle reflections wet-into-wet. This painting provides a good example of transparent watercolor loosely and directly painted without any preliminary pencil drawing.

"Realize who you are and decide on how you want to express your ideas. The uniqueness in each of us is very important. There is plenty of room in the art world for another individualized style or point of view!"

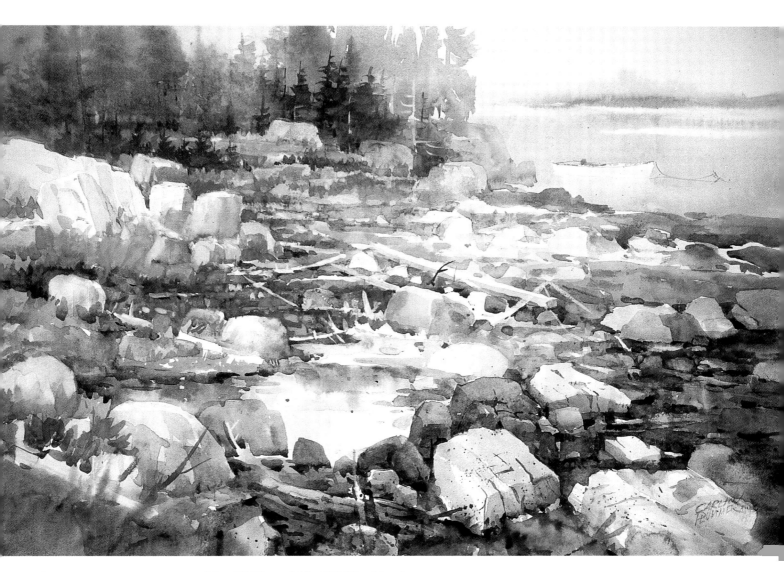

Island Driftwood, 15 x 22" (38 x 56cm)
This was a demo for my Maine workshop executed around 9:00 A.M. on a hazy, misty morning. Because of the filled-in causeway, it's possible to walk onto this pristine and beautiful island to paint. I have been painting this island since 1960 and because of its variety of ground cover, driftwood and pounding surf, I am continually inspired.

About Carlton Plummer

Carlton Plummer was born in Brunswick, on the coast of Maine, and spent his formative years growing up on a farm with his paternal grandparents, aunt and uncle, and his father. His mother died when he was 16 months old. His artistic ability was obvious by age five and was nurtured by family encouragement and books on creating cartoons given to him by his father.

Carlton loved to draw farm animals, but this soon expanded to sketching figures and portraits of people around him. Carlton developed an understanding of and a strong appreciation for the natural environment that has remained with him throughout his life.

High school days involved art-related activities balanced with sports and music. Encouragement from several artist mentors inspired and helped him to stay focused on his artistic goals.

At Vesper George School of Art in Boston, he pursued a major in illustration. It was here that he met and fell in love with Joan, whom he married four years later. He graduated with honors, receiving the Outstanding Student Award in Illustration.

During the Korean War he served in Special Services as an army artist at Fort Jackson. Carlton and Joan were married, and Carlton was later transferred to Germany. Their first son, Barry, was born in Waltham. While overseas, Special Services allowed Carlton time for traveling and painting in many European countries.

After service in the army, he continued as a freelance illustrator in Boston until he enrolled at Massachusetts College of Art, where he earned a BFA in Art Education. During this time their second and third sons, Kevin and Bruce, were born.

With a degree in his pocket, Carlton became a high school art teacher and Director of Art Education in the Chelmsford, Massachusetts school system, where he developed a new art program. He matriculated in a master's degree program at Boston University, graduating Magna Cum Laude with a Master of Fine Arts in Painting. During this period, their fourth son, Gerry, was born.

Hired as an assistant professor of painting at Lowell State College (which later became the University of Massachusetts at Lowell), Carlton began conducting painting workshops around the East. Known for his dynamic personality and passionate commitment to art, his classes and painting lectures, both at Lowell and around the country, were well received. His energy and sense of humor brought dedication and expertise to his popular classes.

Carlton was commissioned by the Department of Military Art to participate in the Army Combat Art program as a civilian painter. Taking a leave of absence from teaching, Carlton was sent to Thailand in 1969. Twelve of his paintings from that trip hang in the permanent collection of the Museum of Military Art in Washington, D.C.

Elected to full professor in 1981, he was an important member of the expanding art department at Lowell during its program formation and helped set the standard for professional excellence.

A reduced workload and several sabbaticals allowed ample time for Carlton to pursue a full-time painting career in addition to his teaching career. Before his very early retirement from the university in 1986, he had achieved national acclaim, winning more than 150 national awards and he was elected to membership in the prestigious American Watercolor Society by his peers.

The building of Joan and Carlton's dream house and noteworthy gardens on the Maine coast was a deciding factor in Carlton's decision to leave the university in order to spend more time in Maine and conduct numerous painting workshops around the US and overseas, including the popular Maine Coast Watercolor Workshops in Boothbay, Maine. Painting and teaching have since taken Carlton and Joan throughout Europe, north to the Arctic, the West Indies, the Greek Isles, Australia, Tahiti, New Zealand, Africa and throughout the US and Canada.

In 1963, Carlton opened the Plummer Gallery in Boothbay, which he and his wife continue to run each summer.

Carlton's paintings appear in more than 20 instructional books and in numerous art magazine articles. His work can be seen in galleries along the Eastern seaboard of the US, and he is represented in several museum, corporate and private collections in the States and abroad. His work has been exhibited throughout the US and overseas, including the Royal Academy of Miniaturism in London; Summer Olympics in Sydney, Australia; Winter Olympics in Nagano City, Japan; and other invitational group shows.

Carlton has won more than 250 national and international painting awards, many of which were gold medals and "best of shows". In addition to his AWS signature membership, Carlton was honored with election to the Miniature Artists of America. Among other distinctions, he was named Professor Emeritus from the University of Massachusetts at Lowell, and has been recognized for his participation in the Civilian Combat Art Program for the army during the Vietnam conflict.

Carlton's philosophy is to continue doing those things that are challenging and rewarding to him, and to spend as much time with his family as possible. Retirement is definitely not on his list! How does one retire from creativity?